IMAGES
of America

LORAIN COUNTY THROUGH THE LENS OF WILLIS LEITER

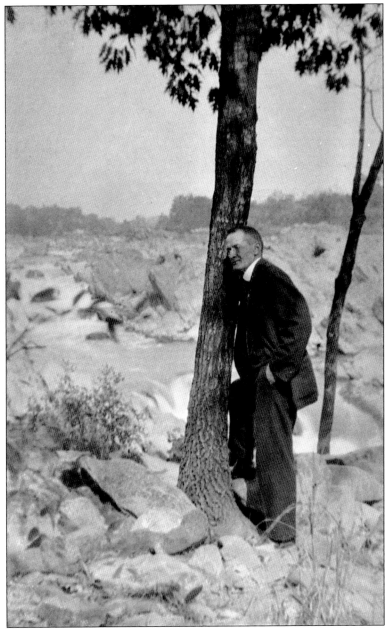

PHOTOGRAPHER WILLIS LEITER, UNIDENTIFIED LOCATION. Willis A. Leiter opened his first Lorain studio in 1901 at 310 Broadway Avenue. Over the years, the studio moved to several other locations on Broadway, including 657 Broadway, later the home of Michael's Studio. In addition to his Broadway studio, Leiter opened studios at 130 Cheapside Street in Elyria and 64 Pearl Street in South Lorain. (Bruce L. Waterhouse Jr.)

ON THE COVER: NO. 6 HOSE CO, L.F.D., LORAIN (363). Firemen, on and about their "combination wagon" and accompanied by their mascots, are captured visiting the Steel Plant General Office. Their trip was from East Thirty-first Street and Palm Avenue to Twenty-eighth Street and Pearl Avenue. Note the interurban car in the background. (Paula Brosky-Shorf.)

IMAGES
of America

LORAIN COUNTY THROUGH THE LENS OF WILLIS LEITER

Bill Jackson, Dennis Lamont,
James D. MacMillan, Paula Brosky-Shorf,
Bruce L. Waterhouse Jr., and
Matthew J. Weisman

ARCADIA
PUBLISHING

ISBN 978-1-4671-0992-5

Published by Arcadia Publishing
Charleston, South Carolina

Printed in the United States of America

Library of Congress Control Number: 2023930907

For all general information, please contact Arcadia Publishing:
Telephone 843-853-2070
Fax 843-853-0044
E-mail sales@arcadiapublishing.com
For customer service and orders:
Toll-Free 1-888-313-2665

Visit us on the Internet at www.arcadiapublishing.com

To Albert C. Doane

Our most admired friend and coauthor of our first Leiter book, Albert C. Doane, sadly passed away on June 4, 2021, at 96 years of age. He was a highly respected local historian who helped found the Black River Historical Society, now the Lorain Historical Society. His vast historical archive of Lorain and its people is at the Lorain Main Public Library. He authored many books, articles, and programs of local history over a full lifetime. He will always be fondly remembered and cherished by the citizens of Lorain and by the coauthors of the first Leiter book, who had the privilege and opportunity to work with him on that project. We were blessed to be recipients of his vast storehouse of knowledge and his nearly century-long collection of memories and stories of the city and county of Lorain.

CONTENTS

ACKNOWLEDGMENTS

The authors would like to thank the following people and organizations for their contributions to this book: Caitrin Cunningham and Jeff Ruetsche of Arcadia Publishing; Frank and Carolyn Sipkovsky, Rodney Beals, Barbara Piscopo, and the many dedicated volunteers of the Lorain Historical Society (formerly the Black River Historical Society); Bruce Waterhouse Sr. and Elmer and Audrey (Waterhouse) Meyers, grandchildren of Willis Leiter; Dr. Charles E. Herdendorf, Sheffield Village Historical Society; Drew Penfield of Lake Shore Rail Maps; Dan Brady, of Brady's Bunch of Lorain County Nostalgia; Loraine Ritchey and Renee Dore of the Charleston Village Society Inc.; Jerry Long, LaGrange historian; Deborah Wagner, 103rd Ohio Volunteer Infantry Civil War Museum; Mark Sprang, Great Lakes Historical Collection, Bowling Green, Ohio; the staff at the Lorain Public Library; Amherst Historical Society; Oberlin College Archives; and Oberlin Heritage Center.

Special thanks to our understanding spouses who supported us through this endeavor: Bernadine Doane, Louise Jackson, Marcy Lamont, Gail MacMillan, Thomas Shorf Sr., Sandy Lusher-Waterhouse, and Barbara Weisman.

INTRODUCTION

HISTORY OF LORAIN COUNTY
The photographs of Willis Leiter featured in this book portray the people, development, cityscapes, and countryside of Lorain County shortly after the start of the 20th century. In addition to our industrial history, Leiter's photographs magnificently capture our immigrant ancestors and their varied villages, churches, homes, schools, entertainment venues, and more. The raw excitement of the times during the short period between 1904 and 1917 comes alive for the viewer in this visual history. We owe Willis Leiter a hearty "Hurrah!" for preserving so well Lorain County's heritage and unique character during this window of time.

Major new industries of the day were being established in Lorain County, including shipbuilding, a world-class steel mill, foundries, auto factories, and all types of diversified manufacturing plants. Agricultural practices matured, producing great advances in productivity and yields. The movement of people and commodities had become easier and more cost-effective with the building of good roads and the development of improved steam and electric railroads. With all this, Lorain County saw unprecedented growth in new homes, businesses, and public facilities, and quickly became a first-class county.

The photographs of Willis Leiter featured in this book portray this growth of the farming villages, towns, and cities of Lorain County. With his keen eye and expert camera work, Leiter captured these revolutionary changes and the spirit of the times that drove this period of growth, which brought a wealth of new people, great minds, innovative ideas, and an educated and dedicated workforce that quickly made Lorain County a force.

REAL-PHOTO POSTCARDS, STUDIO PHOTOGRAPHY
The photographic career of Willis Leiter coincided with the golden era of postcards, and more specifically with the genre's subset known as real-photo postcards. A real-photo postcard is a true photograph produced from a negative and chemically transferred to photographic paper with a postcard backing.

While studio portraiture, examples of which are shown in this book, was likely Leiter's main source of income, he became a prolific chronicler of his age through the capture of natural scenes and man-made structures in his real-photo postcards, which he also offered for sale to the general public. These "view cards" were photographed, annotated, developed, and printed by Leiter from photographs of his home city of Lorain and numerous other locations in Ohio and surrounding states. Like others who pursued this line of business, Leiter was a productive and well-traveled individual. Although over 3,000 of his view cards have been cataloged, it is believed that this may represent only a portion of his portfolio.

The wonder of the real-photo postcard is found both in its documentary history and in its artistic qualities. The captured history is recorded in the content, detail, and moment-in-time aspects of the photograph. The aesthetic value is linked to the composition, visual appeal, and care in preparation and development of the image. We are taken back to the hour and day on which it was taken, and the written message, postmark, and recipient's name and address often found on the reverse add additional depth and context. Our imaginations are stimulated; our understanding of the times

is expanded. Through this presentation of 100-year-old real-photo postcards created by a skilled and sensitive photographer, it is our hope that you too will be transported back in time and that you will grow in your appreciation of Lorain County and its eminent photographic chronicler.

The captions in this book include the numbers that Willis Leiter assigned to identify his real-photo postcards. These numbers appear in parentheses, following the caption written by Leiter. Leiter and his customers used these reference numbers to identify the postcards to be produced or ordered. Today, these numbers help serious postcard collectors track their prized possessions.

BIOGRAPHICAL INFORMATION ON WILLIS LEITER

Willis Abram Leiter was born on March 3, 1866, in Bellevue, Ohio. His father was a tailor, and his mother was a nurse. At the age of 21, Willis married Nettie May Arnold, who was born in Clyde, Ohio, a mere nine days after Willis himself was born. Soon after their marriage, the young couple moved to Cleveland. While they were there, between 1889 and 1895, four children were born.

Shortly after arriving in Cleveland, Leiter found employment as a bookkeeper in a large grocery firm. After a time, the long hours in close confines began to affect his health. Seeing a benefit from a change of lifestyle, the family doctor recommended that Leiter find a new occupation that would take him outdoors and keep him active. Leiter had become interested in photography using cameras that incorporated the latest technology, so he bought one and moved his family to Findlay, Ohio, where oil had just been discovered. John Rowland Leiter, a younger brother, was also a photographer and had established a studio in Vermilion, Ohio. Six of the postcards featured in this book were published by John R. Leiter using either his own or Willis Leiter's photographs.

The exploration for oil became Willis Leiter's photographic subject. He visited the drilling rigs and wells, taking pictures of the gushers and of the workers and their families. During this time, Nettie May cared for three small children (one of the four born in Cleveland had since died), canned hundreds of quarts of tomatoes, and gave birth to twin girls in 1896. One of these girls, Cary May (named after Willis's mother and his wife), was the grandmother of coauthors Bruce L. Waterhouse Jr. and James D. MacMillan, who were the source of much information about the life of Willis Leiter and his family.

Leiter's photographic skills improved, and in 1901, he learned of a photography studio for sale in Lorain. After a satisfactory investigation, he bought it and moved his family to Lorain.

The first Leiter Studio was at 310 Broadway Avenue. As described in a newspaper account at the time, Willis Leiter and his partner, a Mr. Sayre, were "artists of ability" and "gentlemen of pleasing personality." According to local business and telephone directories of the day, the Leiter Studio occupied various shops between 1901 and 1917, each on Broadway Avenue (street numbers 308, 310, 312, 316, 523, 657, and 704), as well as studios at 130 Cheapside Street in Elyria and 64 Pearl Street in South Lorain. Leiter also established a studio in Akron in the 1920s.

In addition to postcards, the Leiter Studio produced a variety of portraits, photographs, and publications, including two booklets, one entitled *Leiter's Souvenir of Lorain, O.*, long a staple of local students studying the history of the city of Lorain, and the second, a commemoration of the Battle of Lake Erie under Commodore Perry.

In 1914, business having steadily improved since the opening of Leiter Studio, Willis and Nettie May, joined by their son Earl J., combined with Clarmont and Hildegard Doane to form the Leiter Studio Company. Doane, who was elected secretary and treasurer of the Leiter Studio Company, was the uncle of Lorain historian Albert C. Doane.

In addition to his knack for photography, Willis Leiter loved to read and had an acute interest in phrenology (now known to be a pseudoscience), which was based on the concept that specific brain areas determine human behavior, personality, and character traits.

In 1921, Willis and his son Warren studied in Pittsburgh and became licensed as chiropractors. Willis Leiter opened a chiropractic office in Elyria in 1922. In 1925, he moved to California, returning to Lorain around 1934. He died in 1942 at the age of 75 in Santa Clara, California, and is buried in McPherson Cemetery in Clyde, Ohio.

One

INDUSTRY, MARITIME, AND TRANSPORTATION

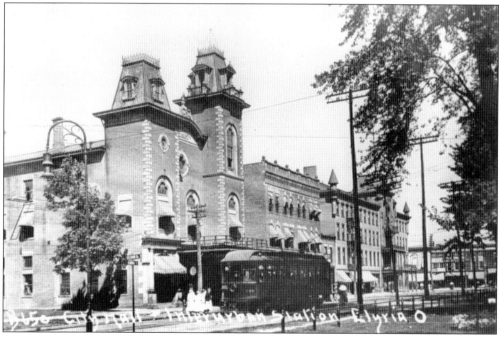

CITY HALL & INTERURBAN STATION, ELYRIA (B650). This photograph shows downtown Elyria's town square, with city hall in the foreground. Known as the "Green Line" due to the distinctive colors of the cars, the interurban station in Elyria provided a transfer point for interurban cars bound for Lorain, Penfield Junction, Amherst, Wellington, Grafton, Oberlin, Norwalk, and Cleveland. (Dennis Lamont.)

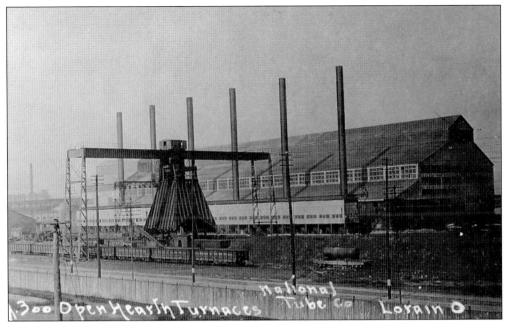

OPEN HEARTH FURNACES NATIONAL TUBE CO, LORAIN (A300). These National Tube open-hearth furnaces were the first at the steel mill. The six 80-ton furnaces were later rebuilt into twelve 220-ton furnaces, making Lorain a major steel producer. Open hearths were the quality steel producers of their day. The open-hearth process was highly polluting, and was eventually replaced by more efficient, cleaner processes. (Bill Jackson.)

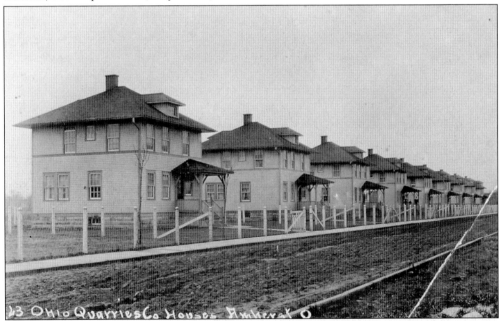

OHIO QUARRIES CO. HOUSES, AMHERST (A23). Ohio Quarries Company built this housing for its workers around 1903 at Buckeye Street and South Amherst Road, also known as North Lake Street. The Buckeye Hotel (not shown here) was on the corner and has since been removed. All of these houses are still in use today and are very well maintained. (Bill Jackson.)

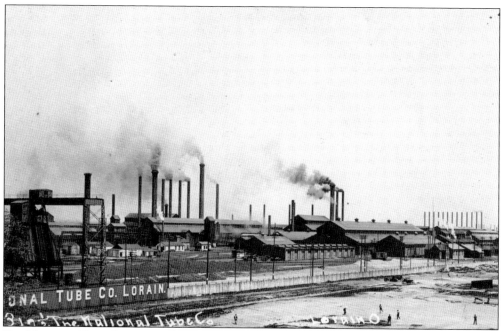

THE NATIONAL TUBE CO, LORAIN (317½). This view of the plant looks west from Pearl Street to the 13 stacks of the welded-pipe mills. The heavily smoking stacks are from the boiler houses of the two blooming mills and the shape mill, which provided steam to operate the huge mill engines. (Dennis Lamont.)

MAN WITH AN AX, LORAIN. With mighty swings of their axes, shipyard workers would soon send a 500-foot ore boat off its building ways into a flooded dry dock. Many special skills were required to build the massive vessels. (Bruce L. Waterhouse Jr.)

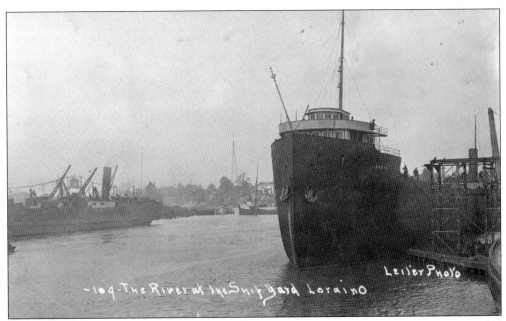

THE RIVER AT THE SHIPYARD, LORAIN (109). An ore boat is tied up at the shipyard, receiving needed repairs. Ship repair was constant work for the yard. Across the river, steam cranes are unloading ore. (Paula Brosky-Shorf.)

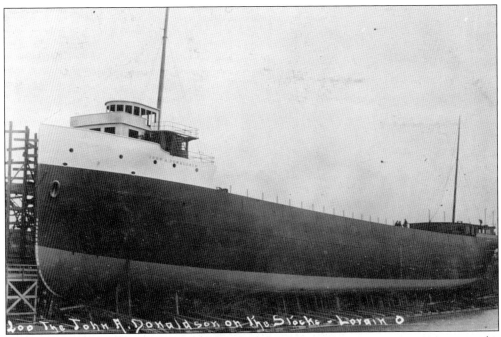

THE JOHN A. DONALDSON ON THE STOCKS, LORAIN (200). In 1908, the ore boat *Donaldson* was under construction for the Valley Steamship Company. At 380 feet in length, she sailed the Great Lakes for 47 years and was scrapped in 1955. (Paula Brosky-Shorf.)

BOW OF THE STEAMER LAKE SHORE, LORAIN (137). The ore boat *Lake Shore* waits at the Lorain shipyard for repairs to her bow after a collision. She was built at West Bay, Michigan, and was owned by the Gilchrist Transportation Company. (Bruce L. Waterhouse Jr.)

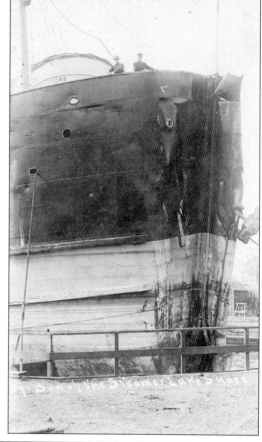

TUBE MILLS NATIONAL TUBE CO, LORAIN (A302). This view of the mill was photographed from Oakwood Avenue and East Twenty-eighth Street looking toward Grove Avenue. The long structure is called the transept building, connecting the skelp mills to the butt and lap-weld mills. The "X" at right marks the location of Nos. 1, 2, and 3 seamless mills. (Paula Brosky-Shorf.)

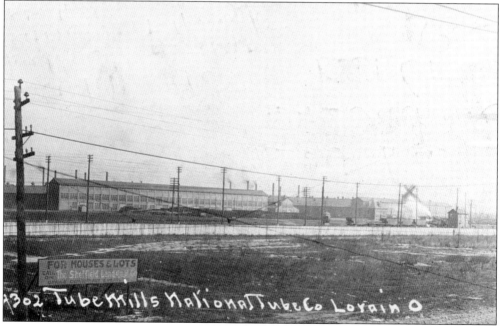

13

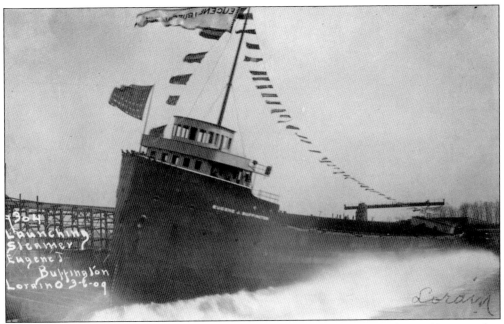

LAUNCHING STEAMER EUGENE BUFFINGTON, LORAIN 3-06-09 (A304). The 580-foot *Buffington* makes a big splash, decked out with pennants and flags of the Pittsburgh Steamship Company. Scrapped in 1980, she had 71 years of service hauling iron ore and coal. (Paula Brosky-Shorf.)

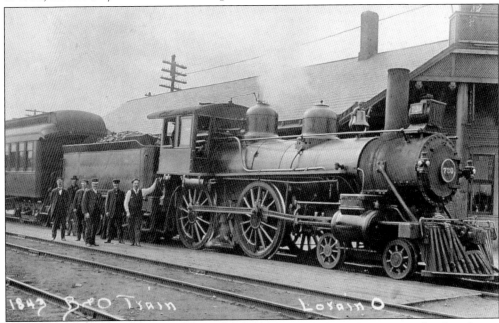

B&O TRAIN, LORAIN (1843). A 1910 passenger train timetable shows four trains a day from Lester to Lorain on the Baltimore & Ohio (B&O) Railroad, two in the morning and two in the evening. The crew in this photograph poses at the B&O/Nickel Plate station in Lorain as the train finishes its northbound run. Engine No. 720, a 4-4-0 American type, will take the train to the old Lorain roundhouse at Forest Street, where it will be reversed and readied for the trip back to Lester. (Bruce L. Waterhouse Jr.)

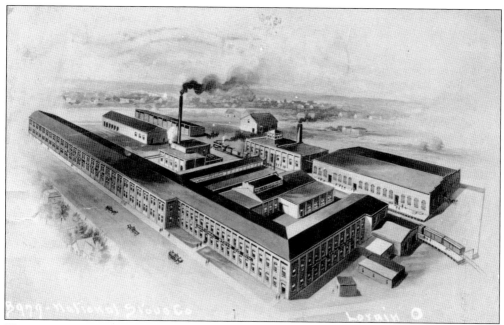

NATIONAL STOVE COMPANY, LORAIN (B979). From 1893 to 1954, many types of stoves and accessories were manufactured on this two-acre site at Long Avenue and Thirteenth Street. Going through many ownership changes, it was under the corporate flag of Magic Chef when the doors were closed in 1954. (Paula Brosky-Shorf.)

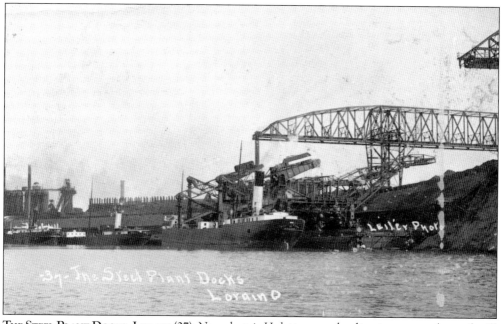

THE STEEL PLANT DOCKS, LORAIN (37). New electric Huletts are unloading iron ore at the steel mill docks. The new Huletts revolutionized the unloading of iron ore. The overhead bridge stored the ore for use. The blast furnaces where the ore was used are on the left. (Bruce L. Waterhouse Jr.)

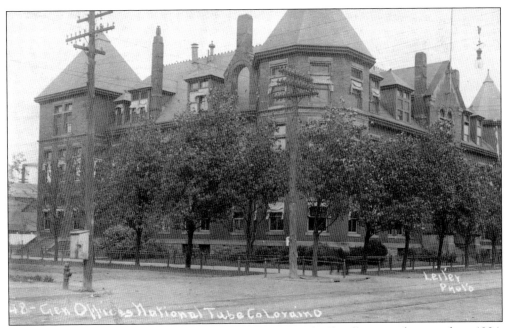

GEN OFFICES, NATIONAL TUBE CO, LORAIN (48). Constructed of locally-sourced materials in 1884, this building was the cornerstone of the steel plant thereafter. Thomas L. Johnson had his office on the first floor, facing the octagonal tower. (Bill Jackson.)

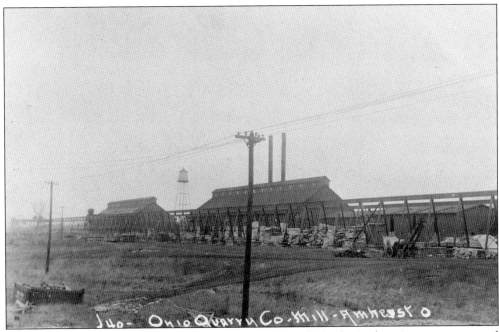

OHIO QUARRY CO – MILL, AMHERST (J40). The finishing mills for the Amherst quarries contained the saws and lathes that provided architectural products for buildings across the country. (Published by John R. Leiter.) (Paula Brosky-Shorf.)

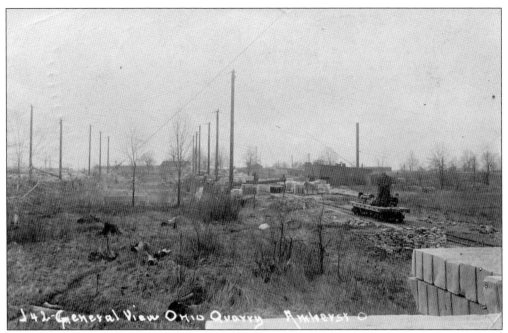

GENERAL VIEW OHIO QUARRY, AMHERST (J42). This photograph shows lifting booms, rough cut blocks, and the railroad cars that extracted and transported thousands of tons of stone every year for building construction across the country. (Published by John R. Leiter.) (Bill Jackson.)

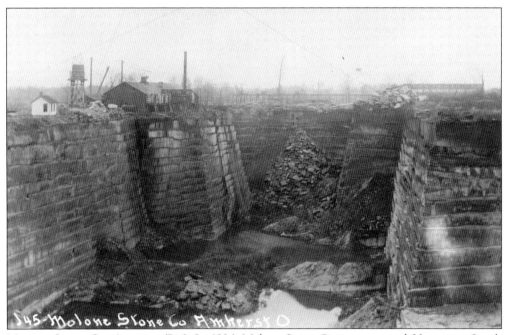

MALONE STONE CO, AMHERST (J45). In 1896, Malone Stone Company owned 20 acres in South Amherst. When the quarry bottomed out, it was 145 feet deep. This view from Quarry Road looking east shows the full depth. The quarry has been out of business for many years. (Published by John R. Leiter.) (Bill Jackson.)

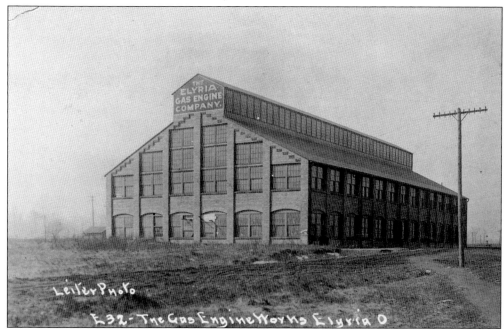

THE GAS ENGINE WORKS, ELYRIA (E32). Opened in 1902, the Elyria Gas Engine works produced gas industrial engines until it closed in 1913. (Paula Brosky-Shorf.)

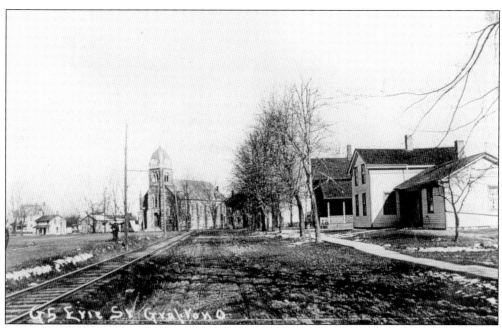

ERIE ST, GRAFTON (G5). This view of Grafton looks north down Erie Street and the Green Line to Elyria. Our Lady Queen of Peace Catholic Church is in the distance. It is a beloved building in Grafton and a "must see" for visitors today. The nearby Cleveland, Lorain & Wheeling Railroad stretched south to the coalfields and terminated to the north at Lorain, feeding coal to the steel mills and Great Lakes. (Dennis Lamont.)

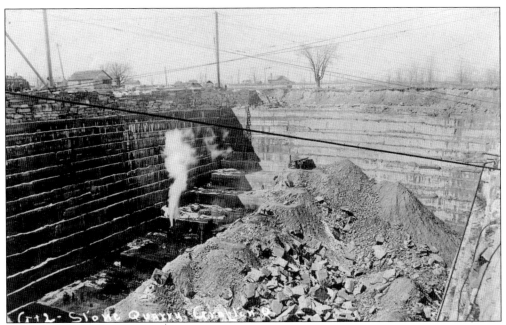

STONE QUARRY, GRAFTON (G12). The largest of several quarries in the area began operations in 1870. Known as quarry No. 24 of the Cleveland Stone Company, it produced flagstone, grindstones, and blocks of Amherst sandstone used in many local bridges, buildings, and breakwaters. A well-known example that survives today is the Lorain County Courthouse in Elyria. (Paula Brosky-Shorf.)

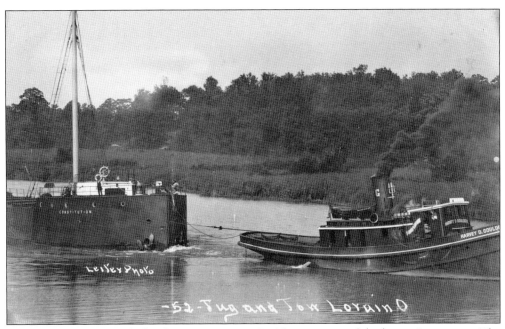

TUG AND TOW, LORAIN (52). The tug *Harvey D. Goulder* is in tow of the barge *Constitution*. The *Goulder* worked the Black River for many years for Great Lakes Towing and was a very popular tug here. In 1917, she worked for the US Shipping Board during World War I. (Bruce L. Waterhouse Jr.)

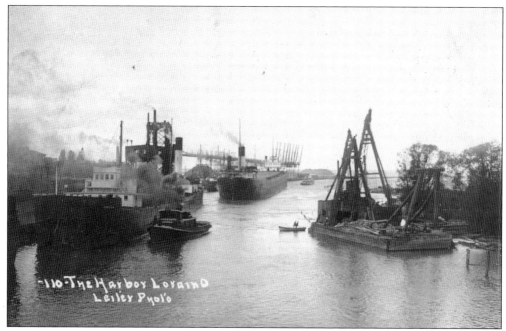

THE HARBOR, LORAIN (110). The Lorain Harbor was a busy place in the early 1900s. It received over a thousand visits a year by the big ore carriers. Iron ore was shipped in for the steel mills, and coal was shipped out for electric plants and industry. The vessel on the right is a dredge that would deepen the river to handle deep-draft boats. (Bruce L. Waterhouse Jr.)

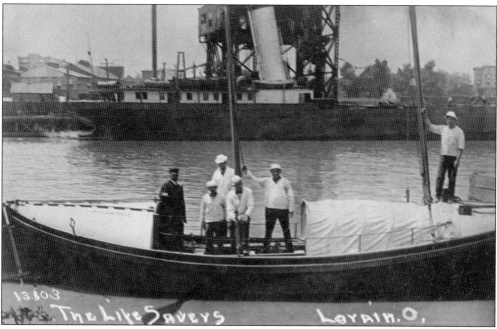

THE LIFE SAVERS, LORAIN. Pictured are lifesaving drills by the US Life-Saving Service. The service would later merge with the US Coast Guard. The boat is an unsinkable lifesaving boat developed for the task. Behind the lifesavers, an ore boat is loading coal at the No. 1 Coal Dump. (Matthew J. Weisman.)

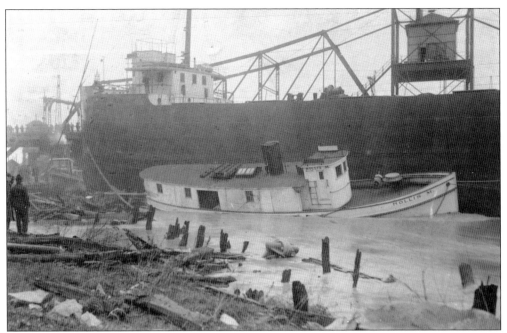

HOLLIS M. AT THE BRIDGE, LORAIN. The 1909 Lorain-built fish tug *Hollis M.* was swamped in a flood on the river at the Erie Avenue swing bridge. She was cleaned up quickly and later became a working tug. She is still in Canadian registry. (Paula Brosky-Shorf.)

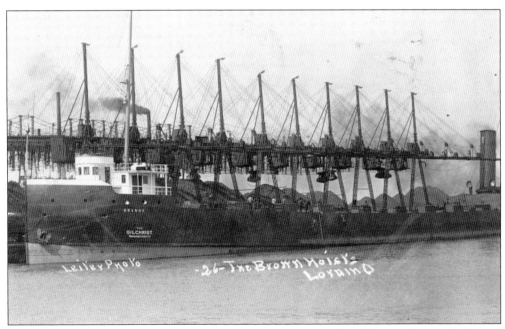

THE BROWN HOISTS, LORAIN (26). The *Uranus* is unloading at the B&O Brown hoists. The booms of the hoists would lower over boat holds, and clam shells would lift the ore from the holds. (Paula Brosky-Shorf.)

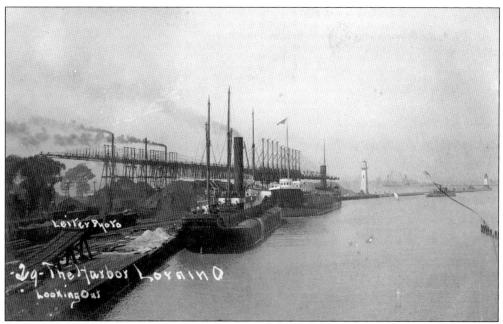

THE HARBOR LOOKING OUT, LORAIN (29). This view shows the B&O ore docks at the head of the river. Steam-operated Brown hoists unloaded the iron ore. The wooden lighthouses can clearly be seen. The boat in the foreground is the British-built *Scottish Hero*. She was torpedoed in the Atlantic in 1917 by a U-boat. (Bruce L. Waterhouse Jr.)

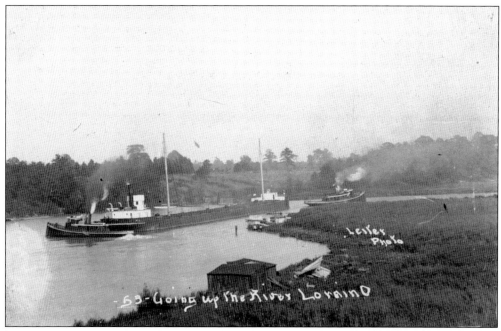

GOING UP THE RIVER, LORAIN (53). The barge *Constitution* is being towed up the river to the steel mill docks. Barges frequently were used to haul coal and ore on the lakes and were guided by lake tugs and other steamboats. (Bruce L. Waterhouse Jr.)

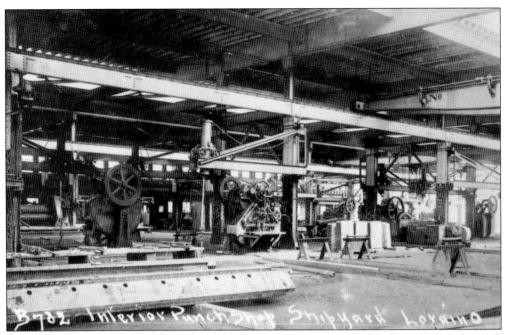

INTERIOR PUNCH SHOP SHIPYARD, LORAIN (B782). This is a view of the machinery used to punch the many holes required in plates and beams so they can be riveted together to assemble a vessel and its components. (Courtesy of Albert C. Doane.)

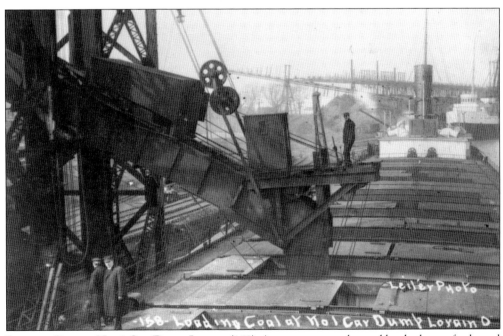

LOADING COAL AT NO. 1 CAR DUMP, LORAIN (158). An operator on the coal-loader boom feeds coal into a freighter's holds. Lorain was a large coal shipper to industries and utilities throughout the Great Lakes for many years. (Courtesy of Albert C. Doane.)

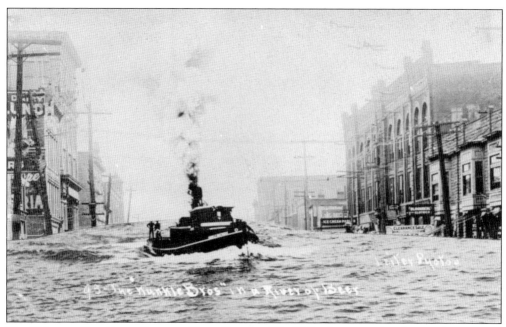

THE "KUNKLE BROS" IN A RIVER OF BEER, LORAIN (93). Willis Leiter used techniques to create a realistic image of an unusual scene. This composite image of the tug *Kunkle Bros.* and downtown Lorain was used to create a spoof card. (Bill Jackson.)

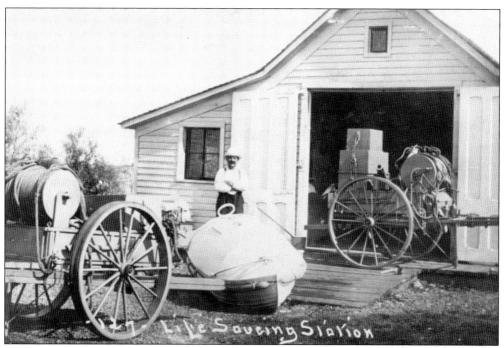

LIFE SAVEING STATION, LORAIN (127). The US Life-Saving Service, established in 1878, was the predecessor to the US Coast Guard Service that came into existence in 1915. The lifesaver in the photograph stands proudly amid the impressive lifesaving equipment of the time. (Paula Brosky-Shorf.)

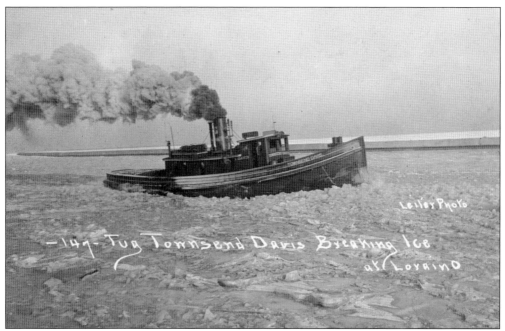

TUG TOWNSEND DAVIS BREAKING ICE AT LORAIN (147). Lorain-based tugs helped keep the harbor and river clear of ice in the winters. The Great Lakes tug *Davis* is shown breaking up ice in the outer harbor. The vessel was dismantled in 1917 by Great Lakes Towing Co. (Paula Brosky-Shorf.)

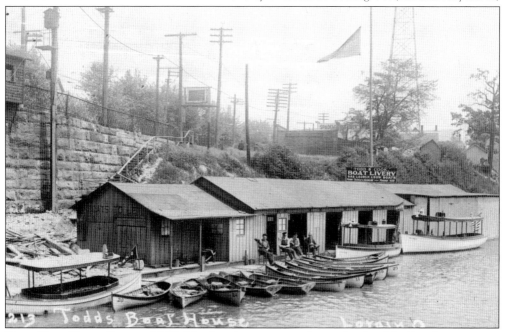

TODDS BOAT HOUSE, LORAIN (1213). This boathouse was on the south side of the Erie Avenue swing bridge. It was owned by Thomas Gawn Todd and Arthur G. Cook. The sign to the right reads, "Todd & Cook Boat Livery – Gas Launch and Row Boats – Fishing Tackle & Gasoline – Phone 449." The gasoline launch *Wanda* waits patiently at far right for the next pleasure cruise. (Paula Brosky-Shorf.)

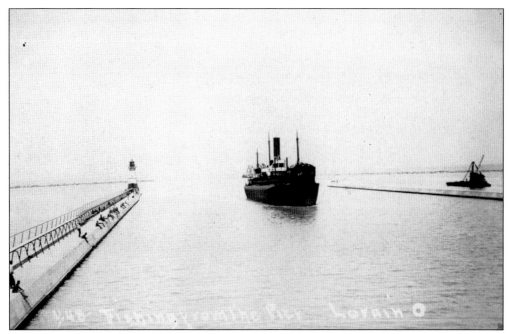

FISHING FROM THE PIER, LORAIN (448). Fishermen are enjoying the day on the pier. The outer lighthouse at the end of the elevated walk is prominent, for use during storms. The walkway had to be repaired every year until the outer break wall was finished and the walk was no longer required. (Bruce L. Waterhouse Jr.)

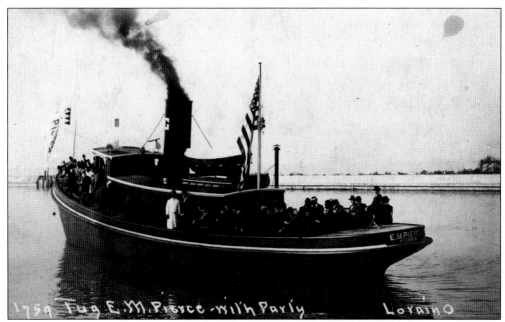

TUG E.M. PIERCE WITH PARTY, LORAIN (1759). This large party is enjoying a leisurely ride in the harbor. The E.M. Pierce was built in 1909 by Great Lakes Towing of Cleveland and remained in its fleet. The mighty tug was later renamed the Utah and scrapped in 1998. (Paula Brosky-Shorf.)

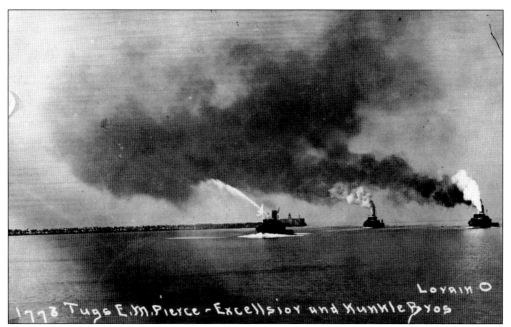

Tugs E.M. Pierce & Excellsior and Kunkle Bros, Lorain (1778). These three Lorain-based tugs are parading into the harbor. One is operating its fire hose for extra effect. Visible in the background is the newly built base for the present-day lighthouse. (Paula Brosky-Shorf.)

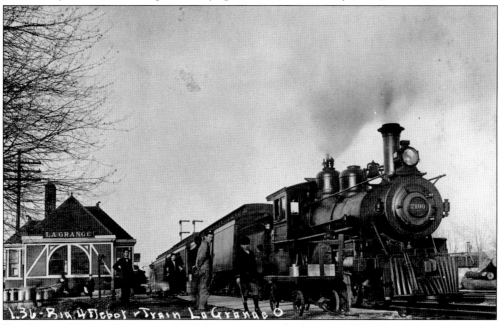

Big 4 Depot & Train, LaGrange (L36). This station was built around 1892 after the previous station burned. The train, a local pulled by locomotive No. 7100, was a standard local train configuration on the "Big Four" line (the Cleveland, Cincinnati, Chicago & St. Louis Railroad). Locomotive No. 7100, an American type, was built in the 1880s and was in service until 1915. Right behind the locomotive tender is the baggage car, ready to pick up anything the station had to ship, followed by the smoking coach and, last but not least, the nonsmoking coach. (Paula Brosky-Shorf.)

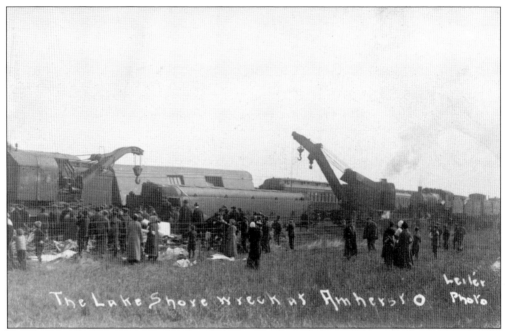

THE LAKE SHORE WRECK AT AMHERST. Three fast passenger trains came together on a foggy morning on March 29, 1916, a mile west of Amherst, Ohio. There were 26 known dead and at least 50 injured in this mishap, drawing gawkers from miles around. Here, the New York Central works to clean up the wreckage and restore service. (Paula Brosky-Shorf.)

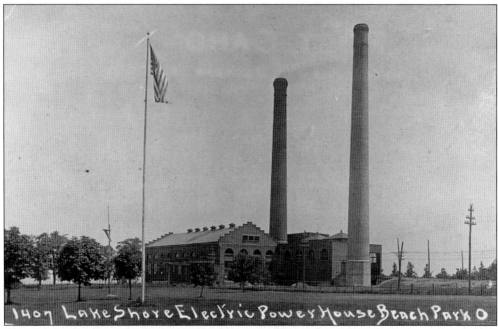

LAKE SHORE ELECTRIC POWERHOUSE, BEACH PARK (1407). Beach Park was on the shore of Lake Erie in Avon Lake. This photograph shows the powerhouse after the installation of new power equipment and a second smokestack in 1907. In 1923, Lake Shore Electric sold the resort property to the Cleveland Electric Illuminating Company. (Paula Brosky-Shorf.)

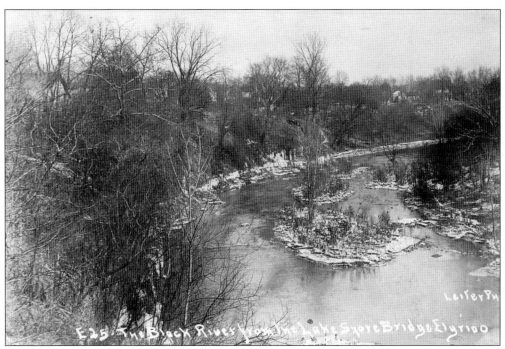

THE BLACK RIVER FROM THE LAKE SHORE BRIDGE, ELYRIA (E25). Here is a view of the west branch of the Black River in Elyria looking north from the railroad bridge. (Paula Brosky-Shorf.)

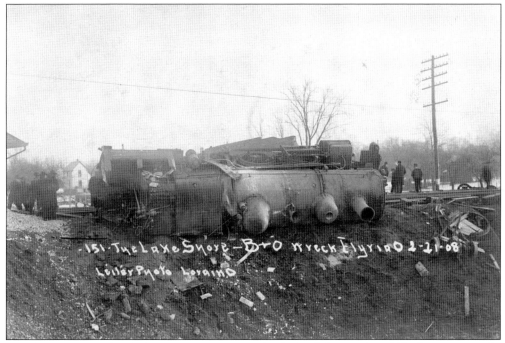

THE LAKE SHORE – B&O WRECK 2-21-08, ELYRIA (151). On February 21, 1908, the engineer of a B&O switcher ignored the signals and pulled into the path of an oncoming Lake Shore & Michigan Southern passenger train at a crossing. (Paula Brosky-Shorf.)

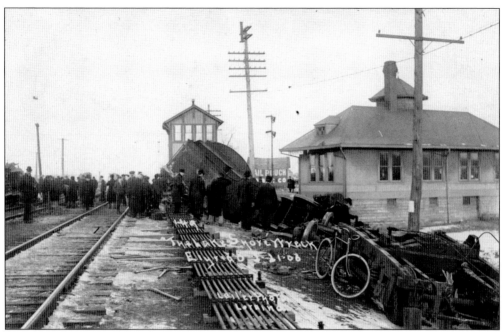

THE LAKE SHORE – B&O WRECK 2-21-08, ELYRIA (149). This view of the February 21, 1908, wreck looks west and shows the tender, the LS&MS locomotive, and the front truck of the baggage car that was following. (Paula Brosky-Shorf.)

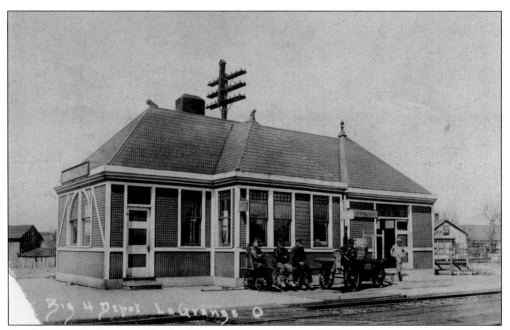

BIG 4 DEPOT, LAGRANGE. This building was erected around 1892 at the corner of Church and Union Streets in LaGrange. It was destroyed by fire in August 1919 and was replaced in 1922. (Paula Brosky-Shorf.)

Two

BUILDINGS, BUSINESSES, STREETS, CEMETERIES, AND BRIDGES

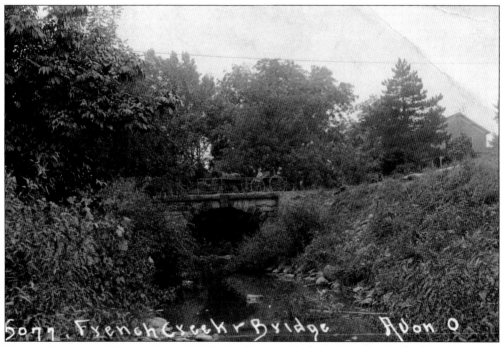

FRENCH CREEK AND BRIDGE, AVON (5077). Looking south down French Creek, this photograph shows a horse and buggy on Detroit Road. Reuben Wilford bought the home on the right in 1850; it later became the Wilford Hotel. The hotel was in business until the 1950s, when it was torn down. Apartments now occupy the site. Long ago, the old bridge also was replaced with a new one. (Paula Brosky-Shorf.)

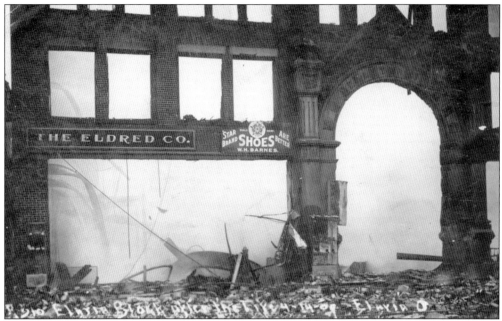

ELYRIA BLOCK AFTER THE FIRE 4-14-09, ELYRIA (A510). Here is the aftermath of the disastrous Elyria Block fire of April 14, 1909, that also destroyed the Medelson Block, the American Theatre, and two frame livery stables. The inferno also damaged the Hotel Andwur and several adjoining buildings. Owner William Heldmyer stated that his insurance covered only half the replacement cost for the Elyria Block. The cause of the blaze was speculated to be faulty wiring. (Bill Jackson.)

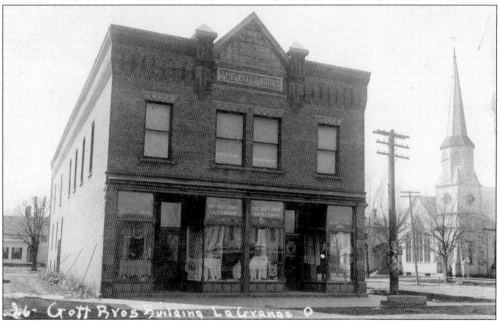

GOTT BROTHERS BUILDING, LAGRANGE (L26). This is the second brick Gott building. The first was built in 1865 by David Gott and George Robbins and was destroyed in a fire in 1897. In 1898, it was rebuilt by David Gott's sons C. Leslie Gott and Ford Gott. The store was in business under the Gott name for 100 years. This fine building is still in use today. (Paula Brosky-Shorf.)

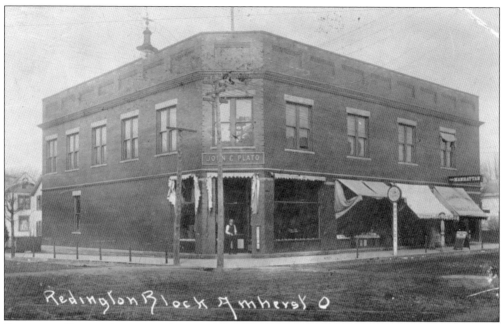

REDINGTON BLOCK, AMHERST. This prominent building was built in 1904 and still stands today on the northeast corner of Elyria and Church Streets in downtown Amherst. The Great Atlantic & Pacific Tea Company operated in this corner building from 1928 until 1939. It housed Fisher Brothers from 1939 through 1966. A pool hall, together with other retailers and a dance hall on the second floor, filled out the building. (Paula Brosky-Shorf.)

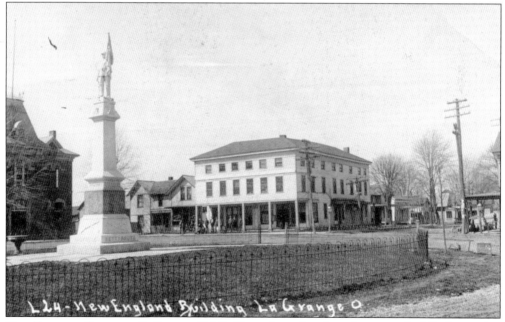

NEW ENGLAND BUILDING, LaGRANGE (L24). Opened as a hotel on the square by J.C. Crittenden in 1830, this building had a barbershop and saloon on the first floor, second-floor hotel rooms, and a third-floor ballroom. Sam and Ruby Naylor owned and ran a grocery store here in 1900. (Bill Jackson.)

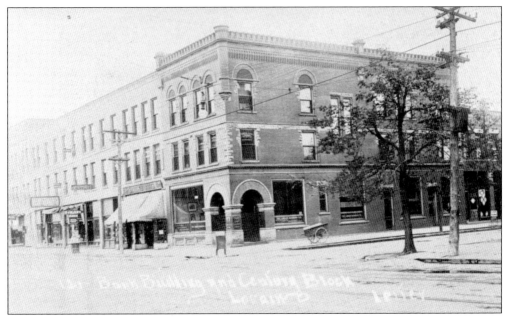

BANK BUILDING AND CENTURY BLOCK, LORAIN (121). This is Sixth Street and Broadway Avenue before major renovations occurred. The bank was remodeled to its present configuration around World War I. The 1924 tornado took the bank's roof off and heavily damaged the post office behind it. In 1928, the Century Block next door was destroyed by fire and was replaced by the Gould Block. (Paula Brosky-Shorf.)

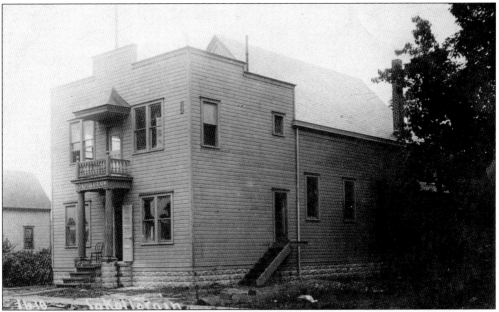

SOKOL LORAIN, LORAIN (1610). Sokol Lorain, or Sokol Hall, was built by the Czechoslovak Society of America in 1908 at 2404 Kelly Place. In 1960, the address was changed to 2400 Kelly Place. The building was later home to the Youth's Center, the Grand International Auxiliary of the Brotherhood of Locomotive Engineers, the Czech Society of America Hall, and several churches, including the current Iglesia de Jesucristo Al Caido. (Paula Brosky-Shorf.)

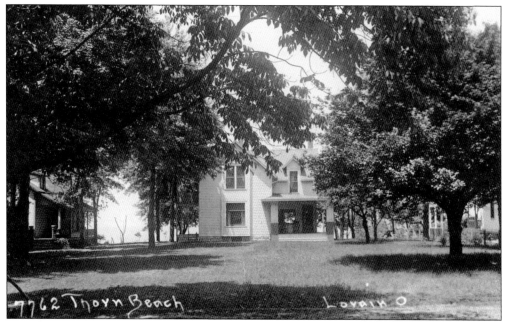

THORN BEACH, LORAIN (7762). Thorn Beach, at 2447 East Erie Avenue, was the home of the Willis Leiter family. The house, built in 1850, stands on .29 acres of land on the shore of Lake Erie. Although a garage has been added, the home looks much the same today. (Paula Brosky-Shorf.)

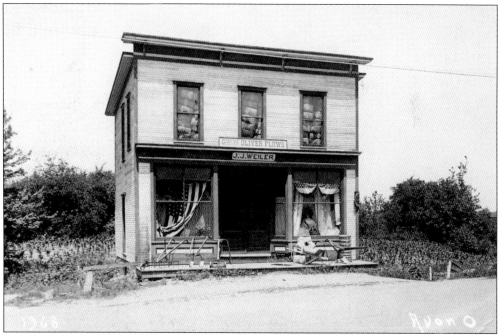

J.J. WEILER BUILDING, AVON (1368). Farm implements adorn the front of this store, which was erected in 1879 and operated for many years by Joseph J. Weiler and his wife, Emma. Constructed in the Italianate style popular at the time, the building is pictured around 1909. Later expanded, it became Bucks Hardware and Supply in 1948. The 143-year-old building was demolished in October 2022. (Paula Brosky-Shorf.)

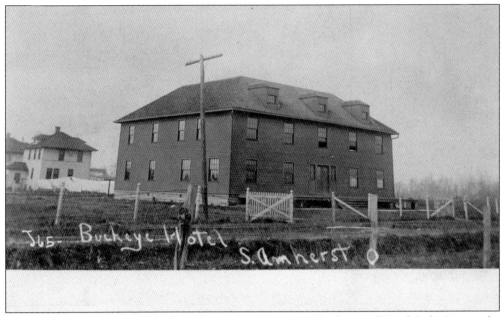

BUCKEYE HOTEL, S. AMHERST (J65). At the southwest corner of Buckeye and North Lake Streets, the Buckeye Hotel was built in 1900 and destroyed by fire in 1961. First used by the quarry company as a boardinghouse, it survived under private ownership until fire destroyed it. The original basement remains today, under a duplex. (Published by John R. Leiter.) (Paula Brosky-Shorf.)

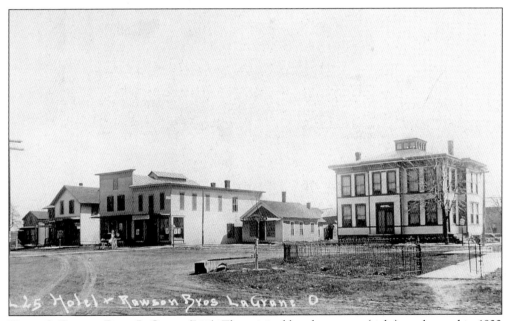

HOTEL & RAWSON BROS, LaGrane (L25). The original hotel structure (right) was burned in 1822 and rebuilt by Robert Wakeman for Allen Curtice. A hotel, saloon, barbershop, and pool hall each occupied the building over the years. Called the Copeland House in 1897, it was torn down in 1944 to make way for houses. Rawson Bros. grocery store on the left was owned by Charlie Rawson. (Courtesy of Bill Jackson).

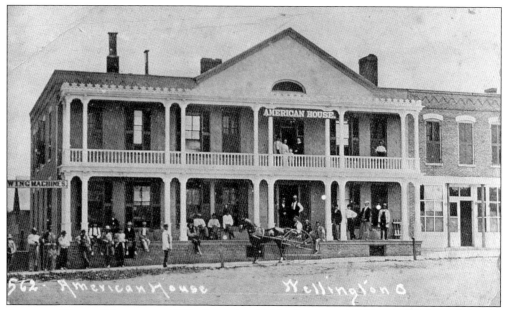

AMERICAN HOUSE, WELLINGTON (562). Erected on Public Square in 1830 by the Wadsworth family, this was the first commercial brick building in Wellington. Later, it became the American House, still owned by the Wadsworth family. It was torn down in 1902, and the Herrick Memorial Library now occupies the spot. (Bill Jackson.)

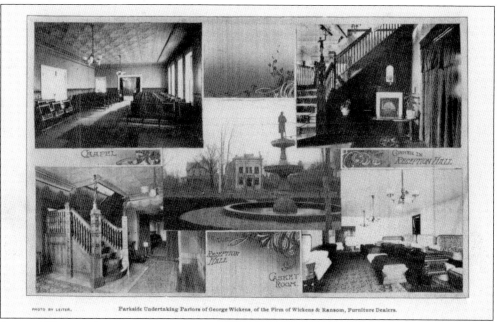

GEORGE WICKENS PARKSIDE CHAPEL, LORAIN. Parkside Chapel housed the undertaking parlors of George Wickens Sr., a former Lorain mayor credited with beautifying the city. The chapel was built around 1903 and designed by Lorain architect Henry O. Wurmser. At 140 West Erie Avenue, it was next to Wickens's residence and across from what is now Veterans' Park. The establishment was the first in the country to offer a sitting room and sleeping apartments for visiting family and friends. This collage of Willis Leiter photographs is from the 1903 book *Lorain* by George Teague. (Dennis Lamont.)

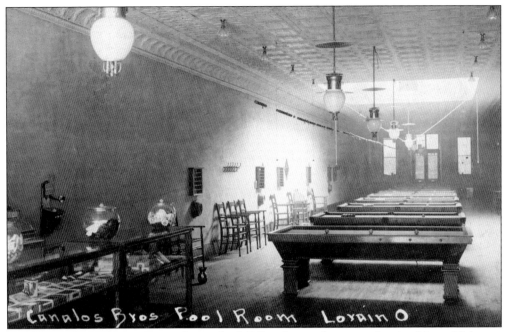

CANALOS BROS POOL ROOM, LORAIN. Located at 343 Broadway in downtown Lorain, this establishment offered billiards, as shown here, and bowling. It was a place for gentlemen to escape from the stress of daily life. (Paula Brosky-Shorf.)

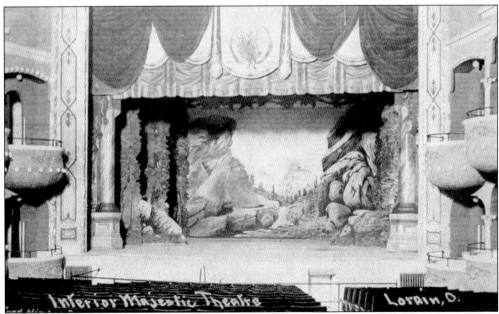

INTERIOR MAJESTIC THEATRE, LORAIN. Renamed the State Theater, this building was the site of 15 fatalities when the roof collapsed during a Saturday matinee on June 28, 1924. The collapse was caused by debris blown onto the roof by the deadly Lorain tornado on that day. A slow collapse allowed almost 300 people in the audience and the piano player to escape. (Paula Brosky-Shorf.)

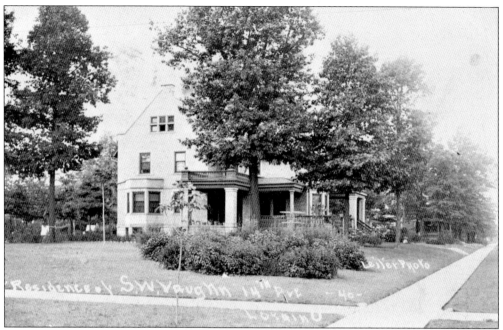

RESIDENCE OF S.W. VAUGHN 14TH AVE (EAST 32ND STREET), LORAIN (40). Samuel W. Vaughn (Vaughen) was the superintendent of the blast furnaces of the National Tube Co. Prior to coming to Lorain, he was employed at Cambria Steel Co. in Johnstown, Pennsylvania. He died in Lorain in 1914 at the age of 63. (Paula Brosky-Shorf.)

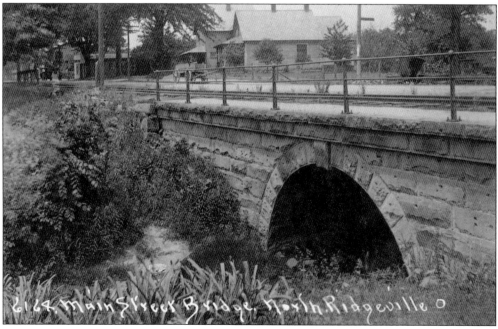

MAIN STREET BRIDGE, NORTH RIDGEVILLE (6164). Sandstone bridges, built with stone from Amherst and other local sandstone quarries, were used extensively all over the county. Many are still in use. This bridge is no longer there; it was removed when the road was widened. (Paula Brosky-Shorf.)

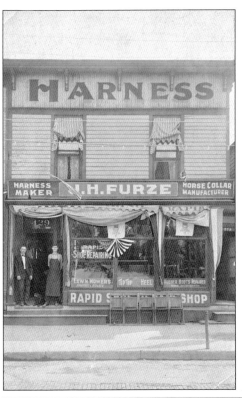

J.H. Furze Harness Maker, Lorain. In 1909, John H. Furze was the proprietor of both this harness business and the Rapid Shoe Repair Shop at 492 Broadway Avenue. Horses were important in those days for many things, including transportation, hauling, and plowing. John and his wife, Fanny, lived at 224 West Erie Avenue. (Paula Brosky-Shorf.)

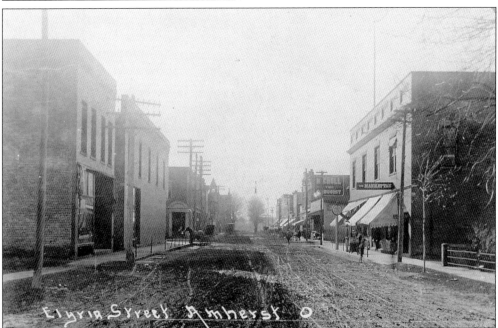

Elyria Street, Amherst. This early Leiter postcard of Elyria Street in Amherst shows the Redington Block on the right. One of the businesses occupying the building was the Manhattan Restaurant. In 1915, Elyria Street was renamed Park Avenue. Note the unpaved and rutted streets, the horse and buggy on the left, and the arc light in the distance. (Bill Jackson.)

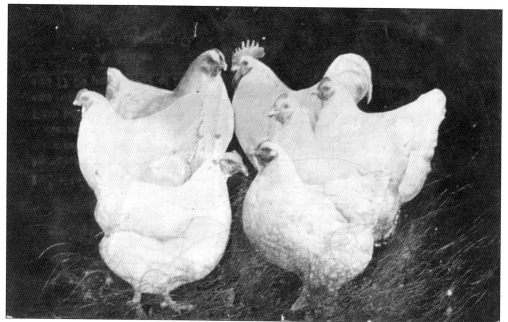

C.A. Miller's Chicken Business. Charles A. Miller lived on Seventh Street in Lorain in 1912. The advertisement on the back of this postcard reads, "Individual photographs grouped together of some of my birds that were raised from a pen that Mr. Kellerstrauss received $1,000 for. I am booking orders for these and other birds at $5.00, $6.00 and $7.00 per setting of 15." The Leiter Post Card Co. produced the card for Miller. (Paula Brosky-Shorf.)

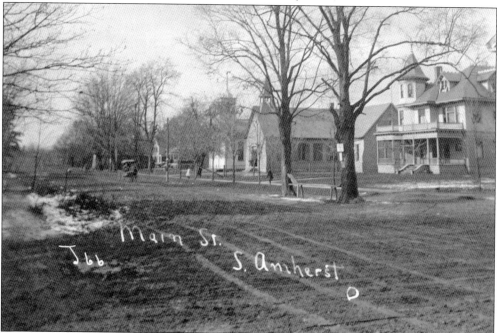

Main Street, S. Amherst (J66). This photograph was taken from the corner of State Route 113 and North Lake Street, looking west. All the buildings in this photograph remain in existence today but without the dirt road or horse and buggy. (Published by John R. Leiter.) (Bill Jackson.)

41

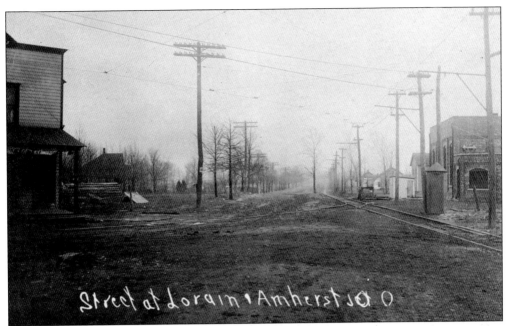

Street at Lorain · Amherst JCT O

STREET AT LORAIN AND AMHERST JCT. Known locally as Penfield Junction because of the tracks for the Green Line Interurban, this intersection provided transportation for workers from Elyria and Amherst to jobs in Lorain. On the right are the Green Line substation and a little telephone booth. Penfield Avenue is to the left, and North Ridge Road, looking south, is directly ahead, continuing to Cleveland Avenue in Amherst. (Published by John R. Leiter.) (Paula Brosky-Shorf.)

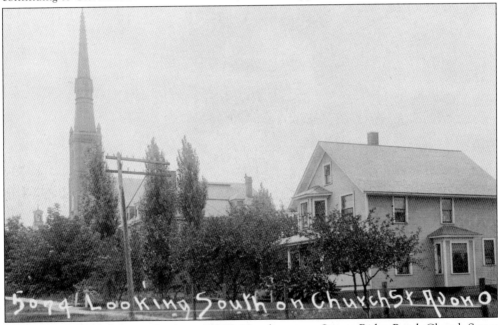

5079 Looking South on Church St Avon O

LOOKING SOUTH ON CHURCH ST, AVON (5079). Now known as Stoney Ridge Road, Church Street is seen here, with St. Mary's Church, built in 1895, in the background. The home at right still looks the same. St. Mary's has a long presence in Avon, as the first wooden church was built on this spot in 1844. (Paula Brosky-Shorf.)

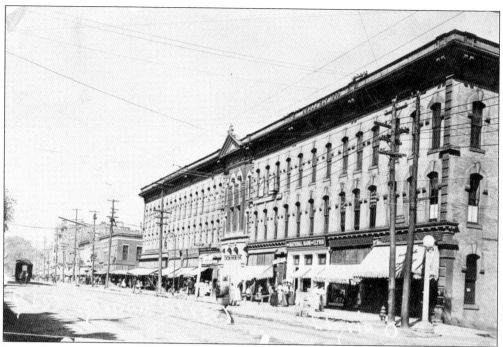

BROAD STREET, ELYRIA (B653). Here is a view of the Heman Ely and Commercial Blocks across from Courthouse Park in Elyria. Waiting to turn into the station on Court Street, a Green Line interurban car from Lorain is in the distance. (Paula Brosky-Shorf.)

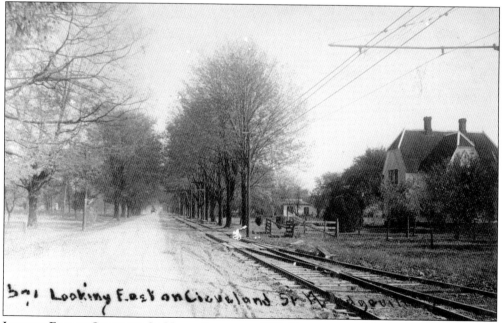

LOOKING EAST ON CLEVELAND ST, NORTH RIDGEVILLE (571). Here is a view of the Green Line interurban tracks along Middle Ridge Road near the border with Elyria. The double-track arrangement allowed eastbound cars to pass westbound cars. Cleveland Street was a designated passing siding on the Green Line timetable. (Paula Brosky-Shorf.)

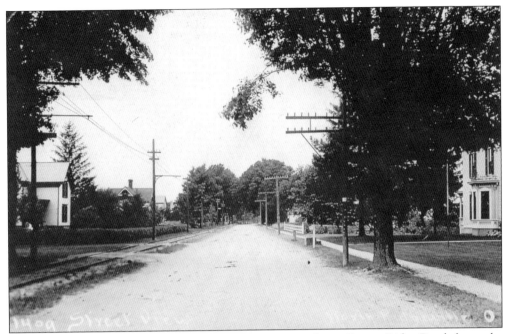

STREET VIEW, NORTH RIDGEVILLE (1409). This street view down Center Ridge Road shows the Green Line trolley tracks. The first run from Cleveland to Elyria was on December 14, 1896. The continuing growth of interurban electric railways eventually allowed passengers to travel all over the state by trolley. (Bill Jackson.)

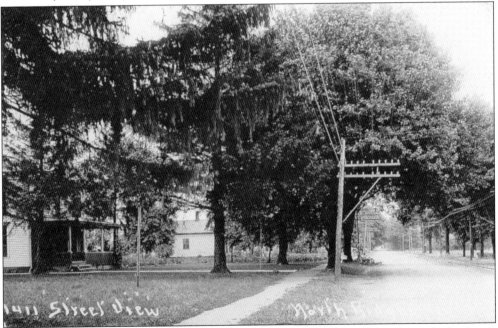

STREET VIEW, NORTH RIDGEVILLE (1411). Here is another view looking down Center Ridge Road. The trolley line can be seen on the right. Many of these old homes still exist. When autos and improved roads came, interurban trolley lines faded away. Willis Leiter traveled on many of the trolleys to take some of the photographs seen in this book. (Bill Jackson.)

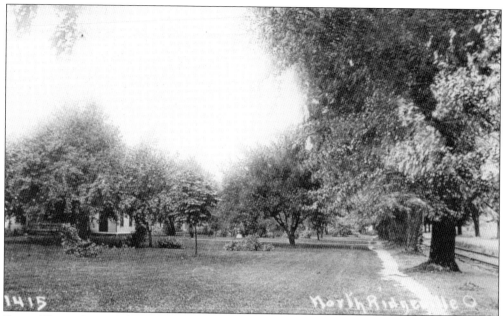

STREET VIEW – RAILROAD TRACKS, NORTH RIDGEVILLE (1415). At the time of this photograph, North Ridgeville was a small collection of buildings along the old stagecoach road from Cleveland to Elyria. The balance of Ridgeville Township was farms and local enterprises. The Green Line interurban tracks running down the side of the road provided all-weather transportation to either Cleveland or Elyria. The next 10 cards have been organized to give the reader a snapshot of the city of Oberlin and Oberlin College prior to World War I. They begin on the east side of town, proceed to the center of town, and then follow the boundaries of Oberlin College to the south and west. (Dennis Lamont.)

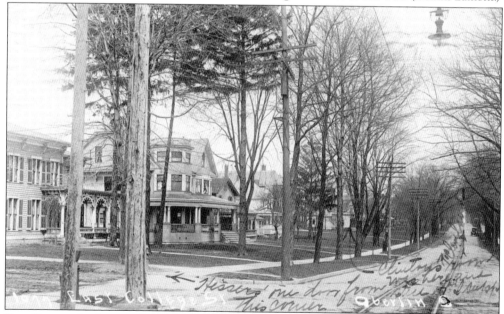

EAST COLLEGE ST, OBERLIN (1077). The Green Line electric railway diverted from the county highway to East College Street in order to reach the center of downtown Oberlin. It was a beautiful ride down tree-lined East College Street past many large homes and college buildings. (Paula Brosky-Shorf.)

45

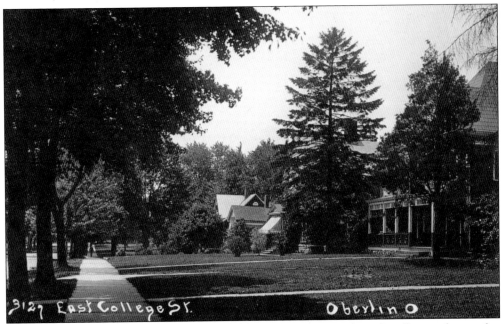

EAST COLLEGE ST., OBERLIN (3127). Continuing toward downtown, this sidewalk view shows a few of the many fine homes on this popular street. (Bill Jackson.)

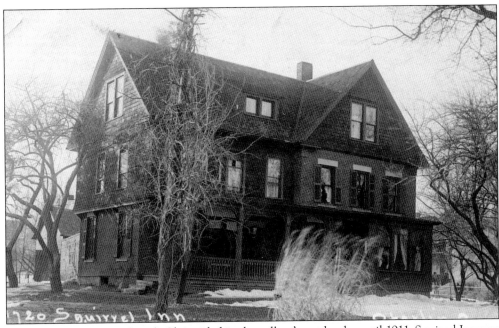

SQUIRREL INN, OBERLIN (1720). Chronicled in the college's yearbooks until 1911, Squirrel Inn was a women's dormitory. It was one of several buildings in Oberlin resembling large residences that served as student housing. (Paula Brosky-Shorf.)

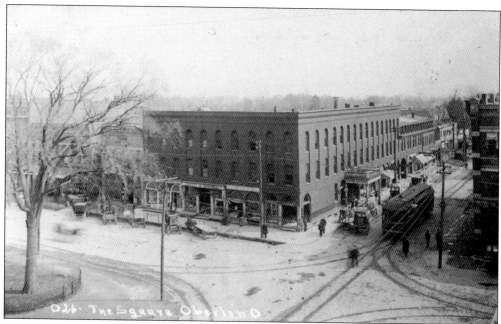

THE SQUARE, OBERLIN (O26). This three-story building was the Park Inn, a 30-room hotel with an interurban station in front. A Green Line interurban car is shown, ready to go to Cleveland after passengers embark and the baggage is loaded. The track in the foreground goes to Norwalk, while the track on the right goes to Wellington. The track on the left is a stub known as "Students Siding" for layover cars. Oberlin's Historic Elm is to the left. (Bill Jackson.)

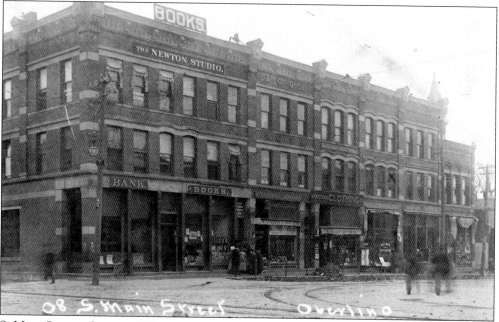

S. MAIN STREET, OBERLIN (O8). At the southeast corner of the square in Oberlin was an eclectic collection of businesses centered on the college. From left to right are the Newton Studio, a bank, a bookstore, the Independent Order of Odd Fellows Hall, the Knights of the Maccabees Hall, J.M. Gardner Druggist, Kellogg Clothing, and a hardware store. (Bill Jackson.)

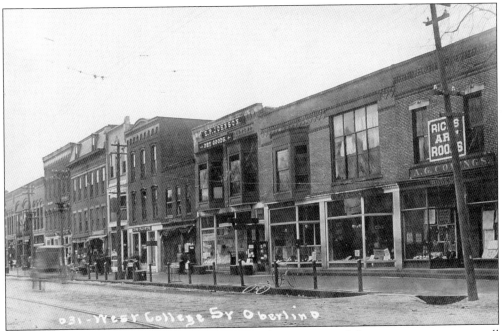

WEST COLLEGE ST, OBERLIN (O31). Facing the southwest corner of the square were many small businesses catering to both the college and the community. From left to right from the center of the photograph are E.P. Johnson Dry Goods, C.W. Persons Drugstore, and the notable A.G. Comings Bookstore. (Bill Jackson.)

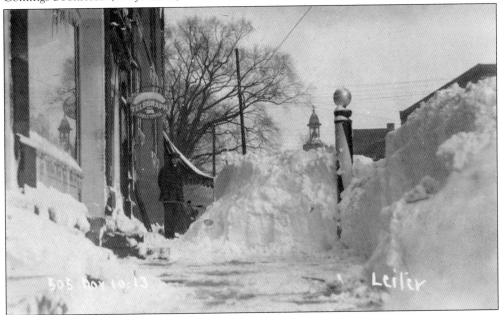

NOV. 10–13, OBERLIN (505). The massive snowstorm of November 10, 1913, blanketed Ohio. Together with railroads and interurbans, most roads were closed until they could be cleared. This photograph was taken on the west side of South Main Street in Oberlin at the telegraph office, looking north. The belfry in the distance was city hall. No doubt the telegraph office, the only reliable long-distance communication at the time, was kept very busy. (Paula Brosky-Shorf.)

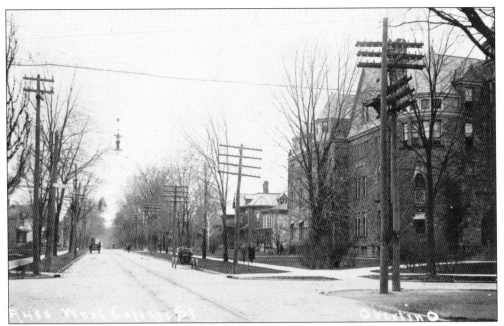

WEST COLLEGE ST, OBERLIN (A488). Looking east is the corner of West College and Professor Streets in Oberlin. The building on the right was Warner Hall, built in 1884 and demolished in 1964. It was replaced by the H.C. King Memorial Hall. The sign on the pole across the street reads, "Cars Stop Here," marking the place to catch a Green Line interurban car. (Bill Jackson.)

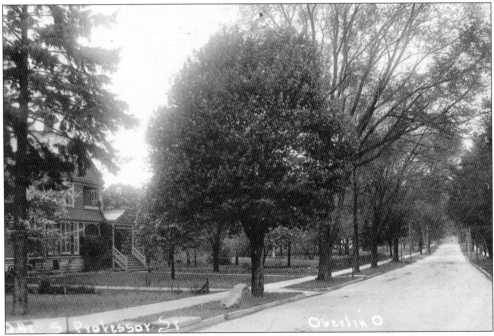

S PROFESSOR STREET, OBERLIN (O41). South Professor Street marks the western boundary of the Oberlin College campus. A nice mix of architecture, with homes large and small, made for a pleasant tour. (Bill Jackson.)

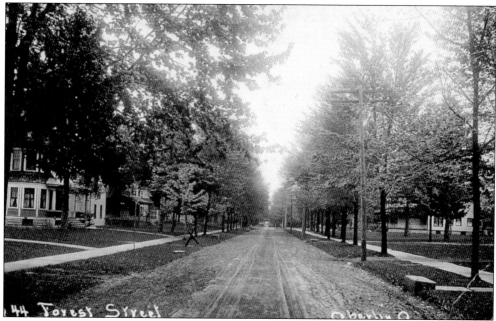

FOREST STREET, OBERLIN (O44). Forest Street serves as a southern border for today's Oberlin College. Only two blocks long, its stately homes today cover a full range of architectural design from the Civil War to contemporary. (Bill Jackson.)

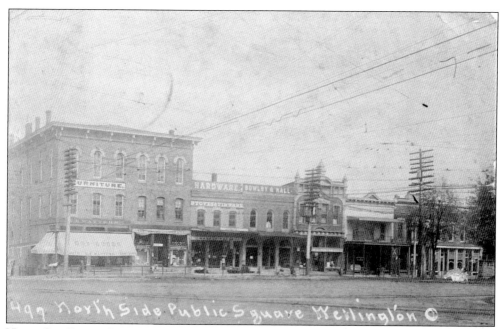

NORTH SIDE PUBLIC SQUARE, WELLINGTON (497). Buildings known as both the Rininger Block and the Horr Block were on the northern corner of Main Street and Mechanics Street (now East Herrick Avenue). The complex burned down in 1915 in one of Wellington's most destructive fires. It housed the J.S. Mallory & Co. furniture store, along with many other businesses. (Paula Brosky-Shorf.)

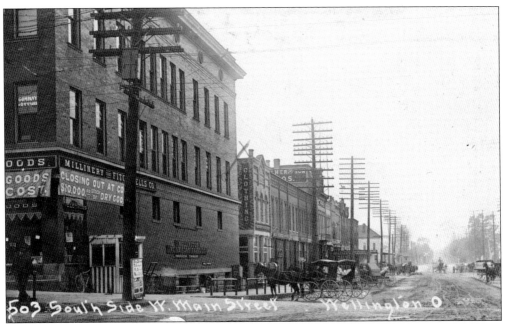

SOUTH SIDE W. MAIN STREET, WELLINGTON (503). This view of West Main Street shows many stores that sold clothing, dry goods, and furniture. Telephone, telegraph, and electric poles line the street, and many horses and carriages bring shoppers to town. (Paula Brosky-Shorf.)

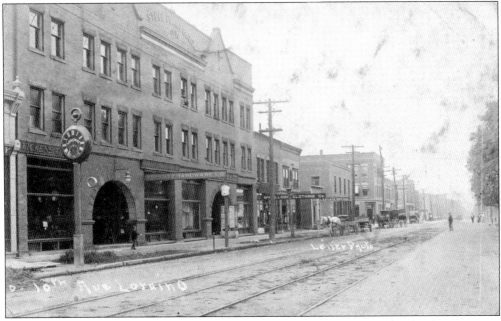

10TH AVE, LORAIN (50). Looking towards Pearl Avenue is a view of the south side of East Twenty-eighth Street. The three-story building on the left was the Steel Plant Block, a mini-mall with a large ballroom on the third floor. These buildings were so named because they were directly across the street from the general offices of the steel plant at the business center of South Lorain. Businesses in the Steel Plant Block were, from left to right, Wickens & Ransom (furniture and undertaking) and Krantz Hardware Co. (Paula Brosky-Shorf.)

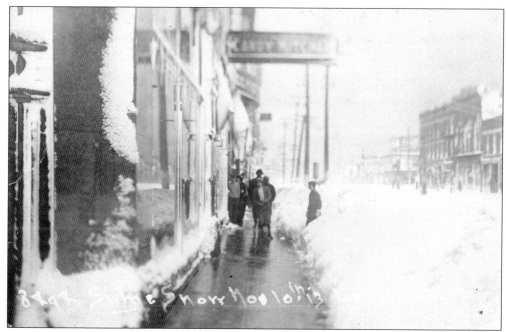

SOME SNOW NOV. 10TH '13, LORAIN (8494). The big blizzard of 1913 brought the normal bustle in Ohio to a screeching halt. Lorain was snowed in for several days until the snow could be cleared. This is what Broadway Avenue, looking north from Fourth Street, looked like. (Bruce L. Waterhouse Jr.)

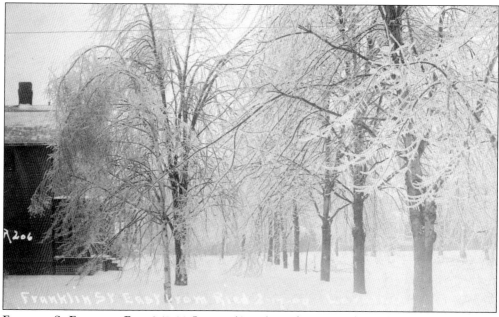

FRANKLIN ST EAST FROM RIED 2-17-09, LORAIN (A206). Looking toward Broadway Avenue, one sees snow on what is now Fifth Street in downtown Lorain. (Paula Brosky-Shorf.)

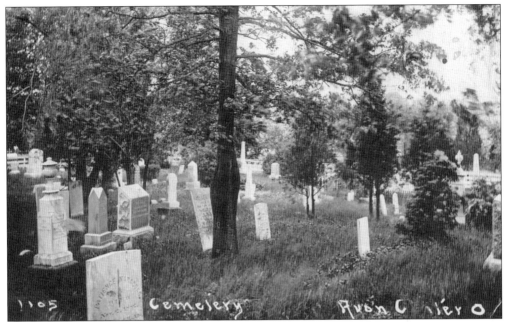

CEMETERY, AVON (1105). Known as Mound or Center Cemetery, this burial ground is at the southeast corner of Routes 254 and 83. The largest public cemetery in Avon Township, it is the final resting place for many of Avon's first settlers. The earliest inscription is that of Lydia M., the only daughter of Lydia and Larkin Williams, who died January 11, 1818, at 15 years, 11 months, and 11 days. One Revolutionary War soldier is buried here, as well as veterans of the War of 1812 and other wars. (Paula Brosky-Shorf.)

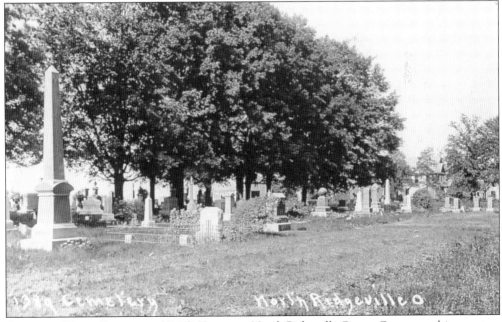

CEMETERY, NORTH RIDGEVILLE (1389). Known as North Ridgeville Center Cemetery, this cemetery is on the northeast corner of Route 20 and Stoney Ridge Road, near the center of North Ridgeville. It is the oldest city cemetery in North Ridgeville and is well-maintained today. (Bill Jackson.)

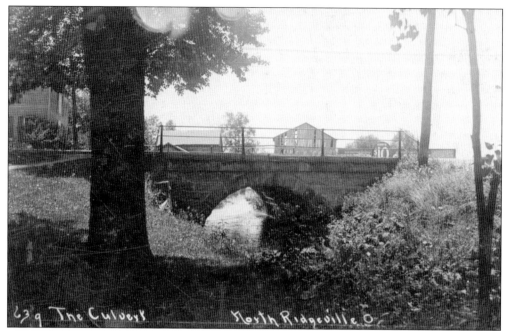

THE CULVERT, NORTH RIDGEVILLE (639). The Mills Road Bridge over French Creek, built in 1881 of sandstone, stood for 140 years until its removal in 2021. The original arch bore the date of 1881 on its keystone. When the city built a new bridge at the site, it saved the old bridge stones. (Paula Brosky-Shorf.)

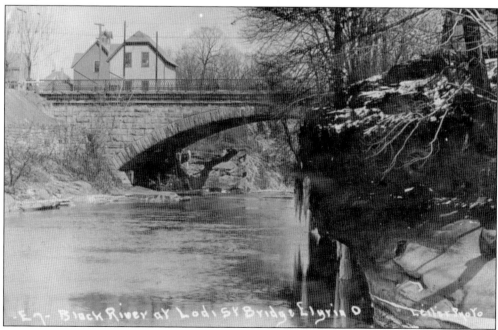

BLACK RIVER AT LODI ST BRIDGE, ELYRIA (E7). This arched sandstone bridge is still in use today. Just beyond the bridge, the river falls 40 feet into Cascade Park. In all, Elyria had seven sandstone bridges. Only one is not in use today, the Washington Avenue Bridge, which fell during a big flood but was replaced. (Paula Brosky-Shorf.)

Three

Public Buildings, City Services, and Parks

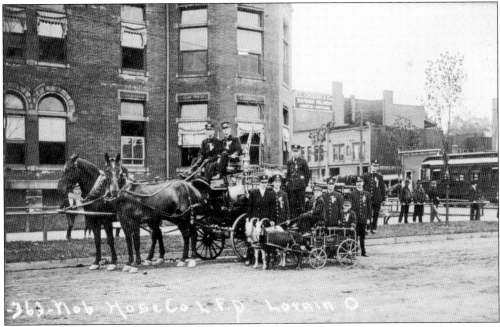

No. 6 Hose Co, L.F.D., Lorain (363). Firemen, on and about their combination wagon and accompanied by their mascots, are captured visiting the Steel Plant general office. Their trip was from East Thirty-first Street and Palm Avenue to Twenty-eighth Street and Pearl Avenue. Note the interurban car in the background. (Paula Brosky-Shorf.)

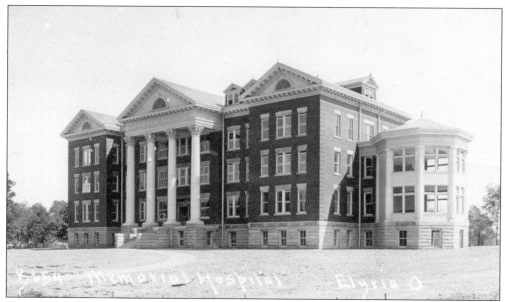

MEMORIAL HOSPITAL, ELYRIA (B654). On Memorial Day 1907, Interurban car No. 129 was headed downtown. Another Interurban car followed close behind. When No. 129 made a stop, the motorman of the car behind did not notice, crashing his car into the rear platform of No. 129, which was packed with passengers; nine died. The grief-stricken community determined to build a hospital, and Elyria Memorial Hospital opened October 30, 1908. Two of the fatalities were children of Edgar "Daddy" Allen and Reverend Sala, who led the building campaign. (Paula Brosky-Shorf.)

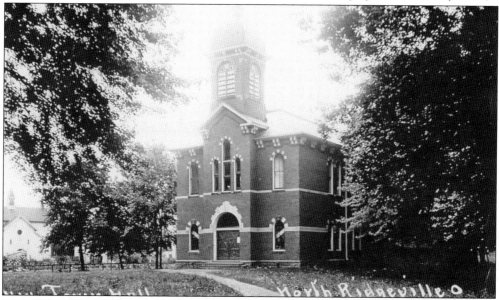

TOWN HALL, NORTH RIDGEVILLE (1414). North Ridgeville's town hall was built in 1882 and dedicated in 1883. Its foundation, trim, and curved window arches were cut from Amherst sandstone. The roof was made of slate; the bell tower was covered with sheets of copper. The lower floor was designed for holding elections and conducting general township business. The second story accommodated public meetings, lectures, concerts, and the like and was constructed with a stage and 298 fine opera chairs on a floor rising back from the stage. The building is still in use today. (Bill Jackson.)

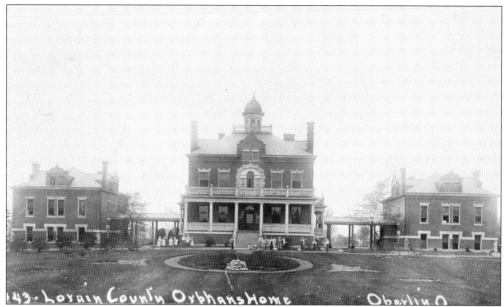

LORAIN COUNTY ORPHANS HOME, OBERLIN (O43). In 1898, Lorain County voters approved a measure to build a children's home. Rev. F.C. Eldred led this effort. Col. J.W. Steele obtained concessions from the City of Oberlin for the home to be built there. The commissioners purchased 15 acres at the corner of Oberlin Road and East College Street, and the Green Acres Children's Home was built at a cost of $32,500. This structure was heavily damaged by the July 1969 wind storms and was replaced with a modern facility. (Paula Brosky-Shorf.)

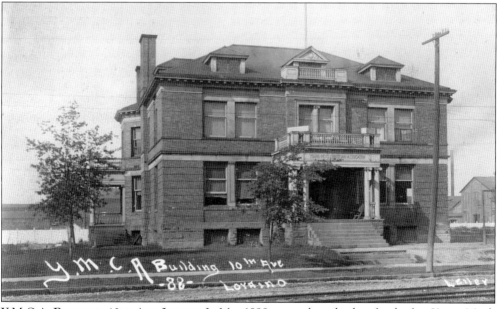

Y.M.C.A. BUILDING, 10TH AVE, LORAIN. In May 1898, ground was broken for the first Young Men's Christian Association in Lorain on Tenth Avenue (later renamed East Twenty-eighth Street). The building was erected at a cost of $29,000 and was dedicated on February 22, 1899, thanks to the efforts of Max Suppes, general manager of the Johnson Company, and his secretary, G.M. Ferguson. The building was replaced by a larger, better-equipped building in 1955 after a fire. (Dennis Lamont.)

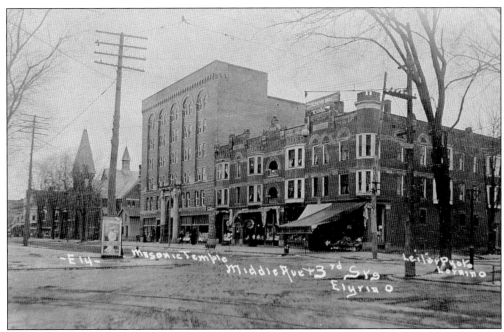

MASONIC TEMPLE, MIDDLE AVE. & 3RD STS, ELYRIA (E14). The Masonic Temple was built in 1905. The masons are Elyria's oldest fraternal organization. Many businesses were located on the lower floor before the beautiful building burned to the ground on March 13, 1956. (Bill Jackson.)

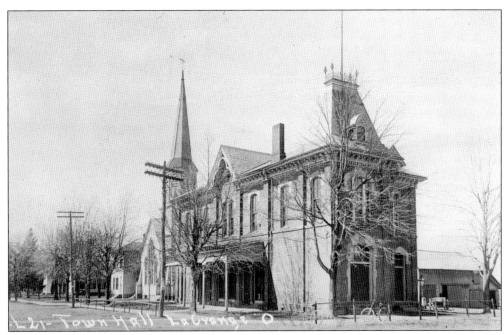

TOWN HALL, LaGRANGE (L21). Built by the village trustees and dedicated in 1874, this Victorian-style building was used for many years as a town hall and for civic activities like plays, graduations, dances, voting, and memorial celebrations. The building has been remodeled, and now houses a recent fire station expansion. (Bill Jackson.)

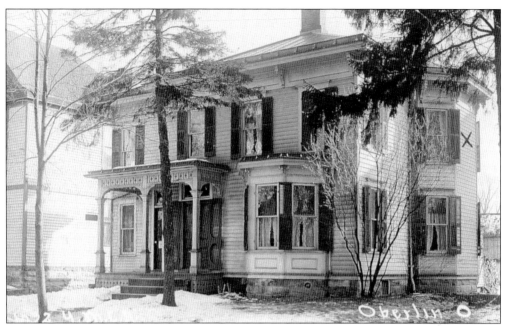

Y.M.C.A., OBERLIN (1732). Oberlin College has had a relationship with the YMCA and Young Women's Christian Association since 1881. The college provided buildings for these organizations in several homes in the campus area. This card shows an example of the home used as the YMCA. The YWCA was in a similar home on Elm Street. (Bill Jackson.)

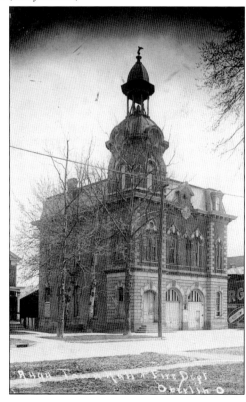

TOWN HALL & FIRE DEPT, OBERLIN (A494). Oberlin's first town hall was built in 1870 at 37 North Main Street. The first floor housed the fire department; city offices were on the second floor. This building was sold to Oberlin College in 1916 and was demolished in 1919. (Paula Brosky-Shorf.)

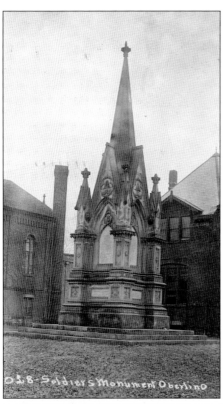

O.28-Soldiers Monument Oberlin O

SOLDIERS MONUMENT, OBERLIN (O28). The Soldiers' Monument was built in 1870 at a cost of $5,000. Prof. Charles H. Churchill of Oberlin College was the architect. It was on the southeast corner of College and Professor Streets. On it were inscribed the names of 96 Oberlin men who died in the Civil War. By 1935, the monument had deteriorated to such an extent as to become unsafe, and it was torn down. (Bill Jackson.)

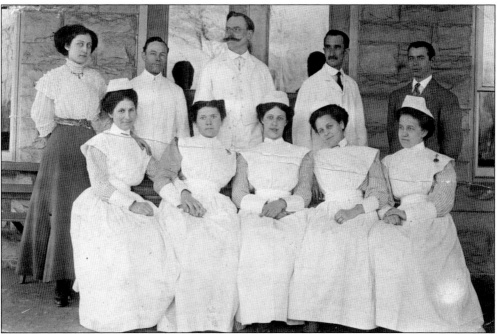

DOCTORS AND NURSES, LORAIN. This c. 1910 photograph captures the medical staff posing in front of a hospital. Nursing uniforms of the day consisted of long-collared dresses covered by stiffly starched white aprons and topped by traditional hats. (Paula Brosky-Shorf.)

NURSE, LORAIN. This picture shows a St. Joseph's Hospital nurse posing for Willis Leiter in one of her daily activities at the hospital. The photograph was most likely used in a flyer or other literature for the hospital at the time. (Matthew J. Weisman.)

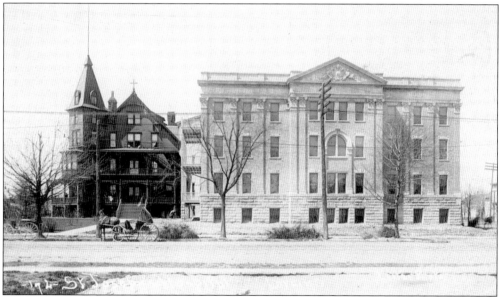

ST JOSEPH'S HOSPITAL, LORAIN (172). St. Joseph's Catholic Hospital was on the west side of Broadway Avenue at Twenty-first Street. The frame building on the left was built as a health resort in the mid-1880s. Later, in 1895, after the resort had failed, Father Bihn of Tiffin bought it at a sheriff's sale. He turned it over to the care of the Sisters of St. Joseph, and Lorain had its first hospital. It became St. Joseph's Hospital in 1903. The new building on the right was built several years later. In October 2015, St. Joseph's Hospital was demolished. (Paula Brosky-Shorf.)

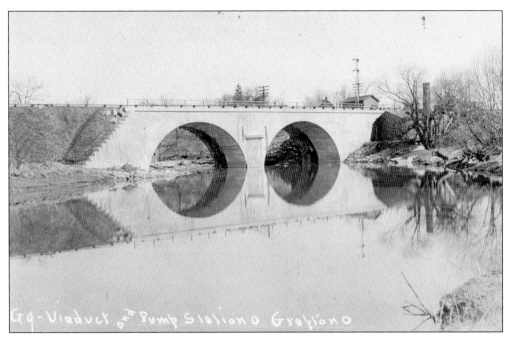

VIADUCT AND PUMP STATION O, GRAFTON (G9). This photograph shows the brand-new concrete bridge that the Big Four Railroad erected next to an older stone bridge. To get water from the river to the water tower in town, a small steam pumping station was built on the riverside next to the bridge. (Paula Brosky-Shorf.)

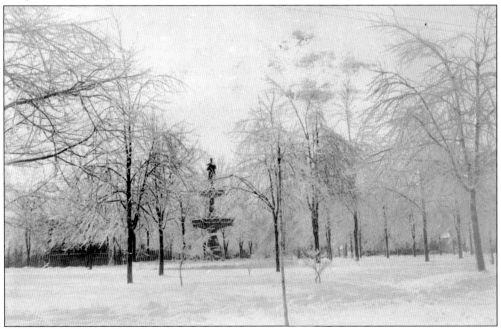

SNOW IN ERIE PARK, LORAIN. Here is a beautiful snow scene in Lorain's first city park. The park has seen many changes over the years. Shown here is the old Civil War monument that eventually deteriorated and had to be removed. Now known as Veterans' Park, it is still beautiful and is much used today. (Paula Brosky-Shorf.)

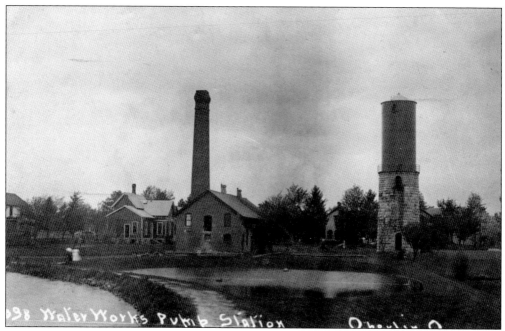

WATER WORKS PUMP STATION, OBERLIN (O38). Oberlin City Water Works, built in 1888, was located on Morgan Street. The Vermillion River was selected as the water source for Oberlin's system and a large reservoir was built that soon provided water to most of the town. The building and standpipe bases are still in existence today. (Bill Jackson.)

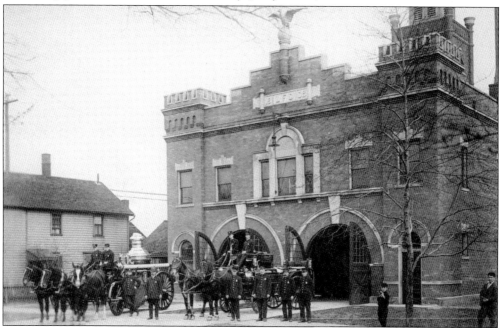

LORAIN FIRE DEPT. NO. 7, LORAIN. In 1918, Station No. 7 boasted a steamer, a chemical wagon, and 10 paid firemen. The station was deemed redundant, and by 1926 became the Salvation Army relief station. Later, the building became the control center for the city health department and was demolished in the 1950s. (Paula Brosky-Shorf.)

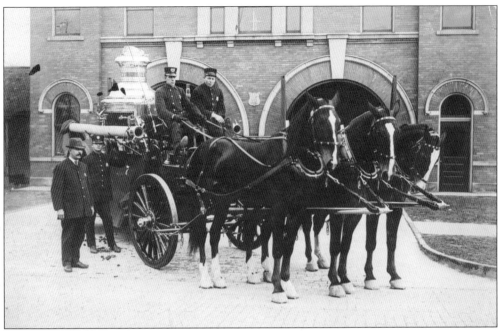

No. 7 Lorain Fire Dept., Lorain. The pride and joy of the station were the three horses that pulled the steam fire engine. Housed in stables behind the building, the horses were always ready to be attached to their special harnesses and to pull the engine to the scene of a fire. (Paula Brosky-Shorf.)

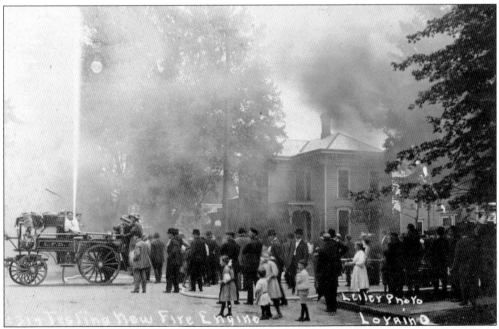

Testing New Fire Engine, Lorain (1517). The Lorain Fire Department is testing its new engine and putting on a thrilling display for Lorain residents. Note the spray of water going straight up into the air near the streetlight. This c. 1910 photograph was taken before fire engines were motorized. (Paula Brosky-Shorf.)

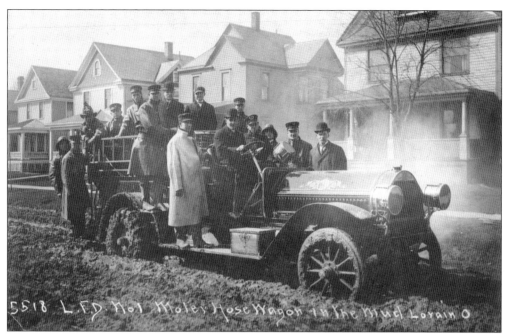

L.F.D. No 1 Moter Hose Wagon in the Mud, Lorain (5518). By 1915, the Lorain Fire Department had motorized most of its fire stations. At this time, many of the secondary roads remained unpaved. The fire department had to be prepared to travel in any kind of weather, hence the chains on the rear wheels. (Bill Jackson.)

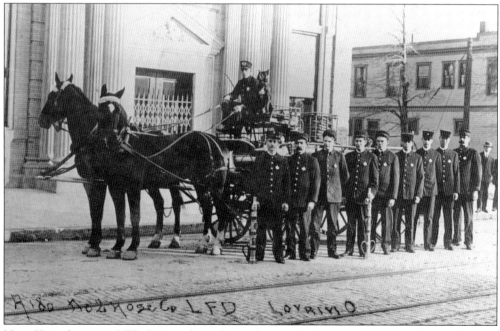

No 2 Hose Company LFD, Lorain (A180). Fire Station No. 2 was at 1814 Broadway, so it was a short run down to the bank on Twenty-first Street to pose for this photograph. In 1914, two horses, a chemical wagon, one paid man, and nine volunteers occupied the station. (Paula Brosky-Shorf.)

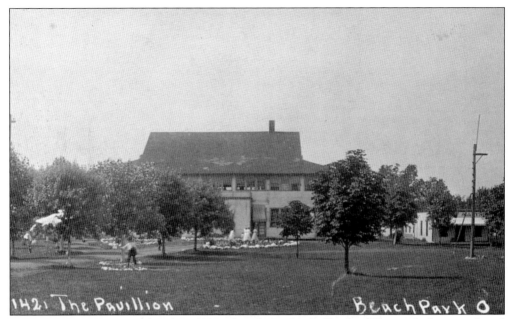

THE PAVILLION, BEACH PARK (1421). In 1897, when the Lorain & Cleveland Electric Railway purchased 184 acres in what was then Avon Township, the plan was to build a powerhouse, maintenance facilities, a station, and a pleasure park on the shore of Lake Erie. Operating under the ownership of the Lake Shore Electric Railway, the park continued to draw riders until 1923, when the property was sold to Cleveland Electric Illuminating for its new power plant. (Paula Brosky-Shorf.)

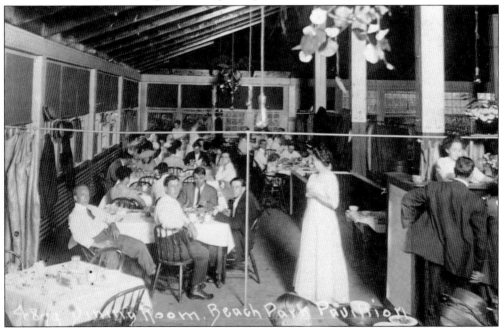

DINING ROOM, BEACH PARK PAVILION, BEACH PARK (4879). What would make a day in the countryside more complete than a home-cooked meal in the Pavilion at Beach Park? Fresh, locally sourced ingredients made for outstanding daily meals. Quick trips home were guaranteed by the Lake Shore Electric Railway. (Paula Brosky-Shorf.)

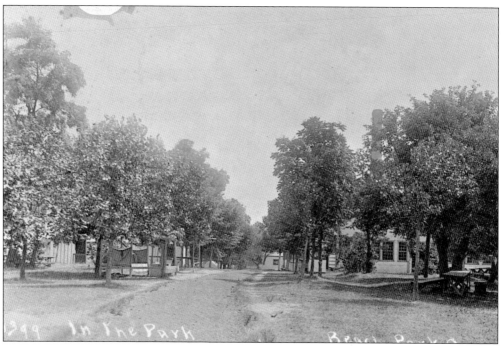

IN THE PARK, BEACH PARK (1399). This view shows the entrance to Beach Park directly across from trolley stop No. 65. To the left are the scenic grove and campgrounds, and to the right are the pavilion, bowling alley, and ball fields. (Bill Jackson.)

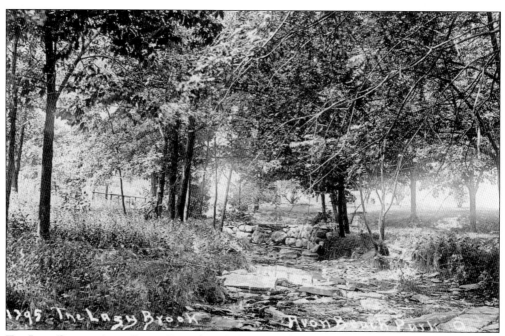

THE LAZY BROOK, AVON BEACH PARK (1395). Avon Beach Park, now Miller Road Park, was a very popular park in the summer with its wide beach. The Lakeshore trolley went right past it, bringing picnickers and bathers out on fine summer days. (Paula Brosky-Shorf.)

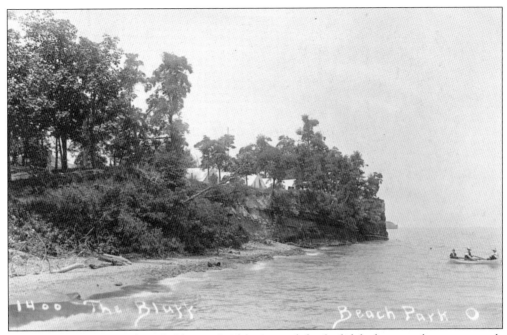

THE BLUFF, BEACH PARK (1400). Chosen for the view and the fresh lake breezes, the tent grounds at Beach Park were the ideal place to enjoy Lake Erie in the summer. (Bill Jackson.)

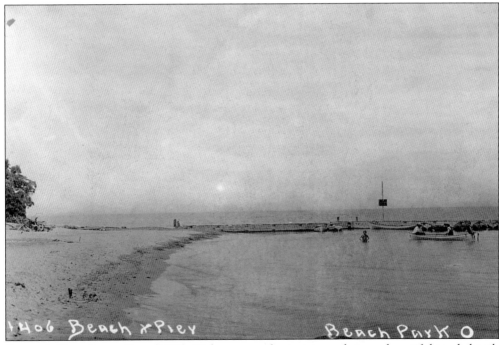

BEACH & PIER, BEACH PARK (1406). Right next to the tent grounds was a beautiful sandy beach protected by a breakwater. Swimming and boating added to the attractions at this popular summer resort. (Paula Brosky-Shorf.)

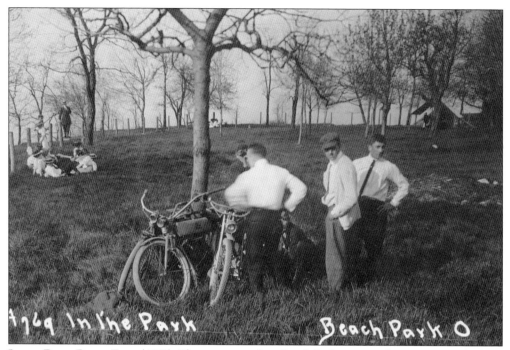

IN THE PARK, BEACH PARK (4769). The tent grounds at Beach Park were in a large grove overlooking Lake Erie. If not staying in a tent, one could enjoy the day with a great picnic. Motorcycle enthusiasts could also stop and rest there. (Paula Brosky-Shorf.)

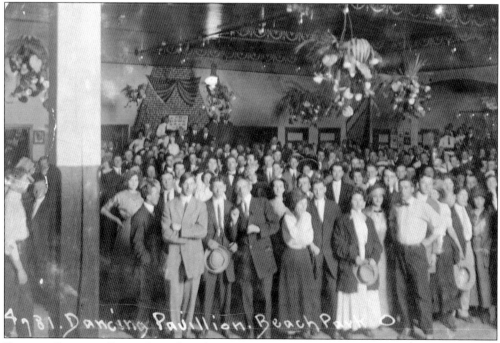

DANCING PAVILION, BEACH PARK (4781). Dinner upstairs and dancing downstairs and then an enjoyable ride back to town on the Lake Shore Electric—what better way to enjoy a Sunday? (Paula Brosky-Shorf.)

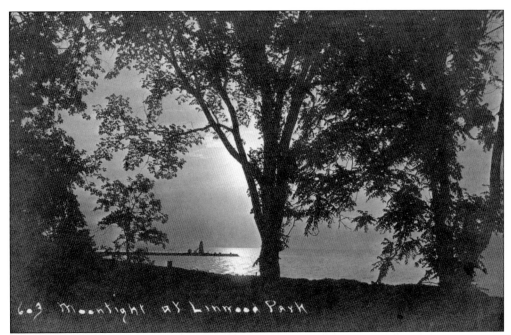

MOONLIGHT AT LINWOOD PARK, VERMILION (603). Linwood Park, so named for its linden trees, was founded in 1874. This evening view shows Lake Erie with the Vermilion lighthouse in the distance. The property boasts a fine beach, available to the current residents for a small admission fee. (Paula Brosky-Shorf.)

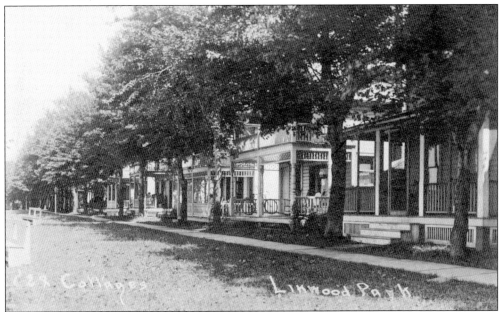

COTTAGES, LINWOOD PARK, VERMILION (624). The park was founded by members of the Evangelical Association as a place to hold Sunday school assemblies, church conferences, and other religious services in a Chautauqua-like setting. It continued to be used by the United Methodist Church through the 1990s. Today, Linwood is a park of privately owned cottages, with a beach and many other amenities. (Paula Brosky-Shorf.)

70

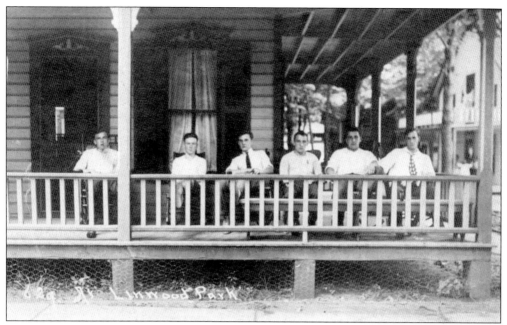

AT LINWOOD PARK, VERMILION (629). These men are enjoying a summer day at one of the Linwood cottages. Religious programs and many other events were held during the summers. Now operated by the Linwood Park Company and maintained by a superintendent, the park is accessible to the public for an admittance fee during the season from early June until Labor Day. (Paula Brosky-Shorf.)

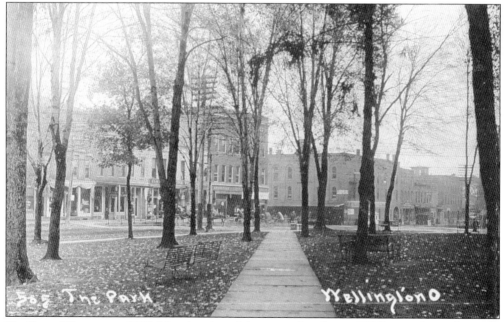

THE PARK, WELLINGTON (505). Here is a view of the city park in front of Wellington Township Hall, bordered by Main Street and Herrick Avenue. It is still used as a small park today. (Bill Jackson.)

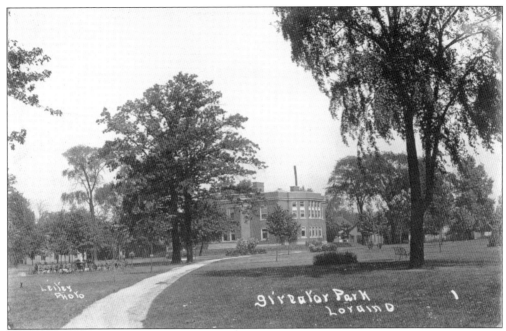

STREATOR PARK, LORAIN (1). Worthy S. Streator was president of the Lake Shore & Tuscarawas Railroad, the railroad that brought Lorain back to life in 1874. He donated a large tract of land in Lorain for use as a park, which became Streator Park. In 1924, the Lorain Library Committee selected the park as the location of the proposed Carnegie library. The building at 329 West Tenth Street is now home to the Lorain Historical Society. (Bruce L. Waterhouse Jr.)

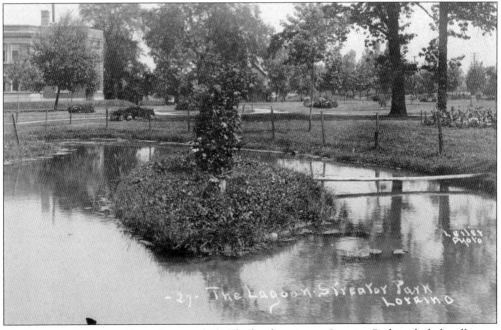

THE LAGOON, STREATOR PARK, LORAIN (27). The landscaping at Streator Park included walkways, flower beds, a fountain, and a lagoon. The old Carnegie library can be seen in the background on the left. (Bruce L. Waterhouse Jr.)

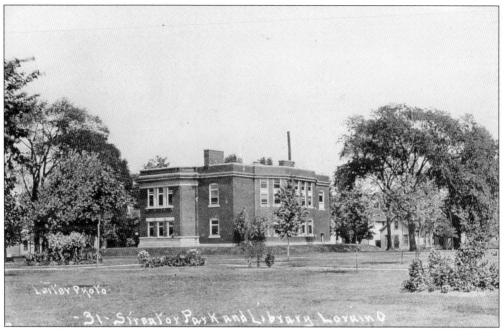

STREATOR PARK AND LIBRARY, LORAIN (31). This is the Carnegie library, as conceived and built by the Lorain Library Committee in 1924. In August 2013, the Lorain Historical Society collaborated with the City of Lorain, Lorain City Council, and the Lorain Port Authority to acquire the building. (Bill Jackson.)

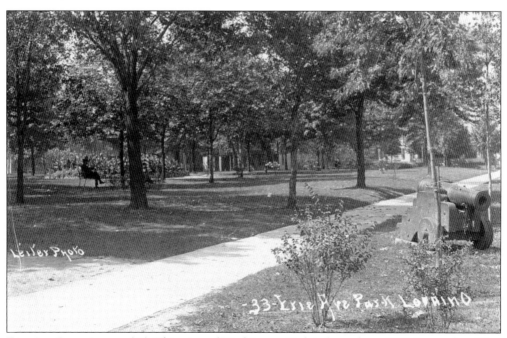

ERIE AVE PARK, LORAIN (33). This view of Washington Park is from about 1910. Located on West Erie Avenue at Washington Avenue, it has been refurbished as Veterans Memorial Park. Note the gazebo in the background and the cannon on the right. (Bruce L. Waterhouse Jr.)

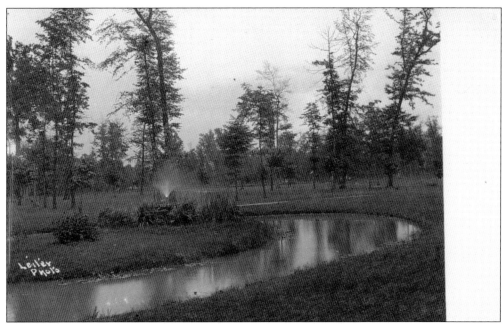

THE FOUNTAIN, OAKWOOD PARK, LORAIN (44). In 1894, the Sheffield Land Company donated an eight-block tract in south Lorain to the city for a park. Through various legal actions, the city was finally able to take control of the park in 1915 and began to give it the configuration that it has today. (Bruce L. Waterhouse Jr.)

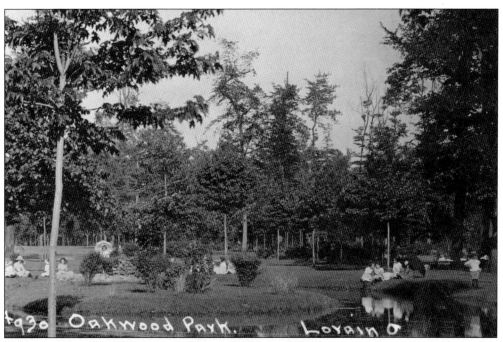

OAKWOOD PARK., LORAIN (4930). Walkways, a bandstand, and lagoon were built among the mighty oak trees that gave the park its name. The beautiful park along Grove Avenue between Thirty-first and Thirty-sixth Streets remains a pleasant getaway today. (Paula Brosky-Shorf.)

Four

CHURCHES AND SCHOOLS

CATHOLIC CHURCH, AMHERST (A15). St. Joseph's Catholic Church had its beginnings in the mission church of Fr. Louis Melon. Father Melon traveled from St. Mary's in Elyria to say Mass in the small Amherst community. In 1864, the mission church became St. Joseph Parish. The church shown here was built in 1868 and served the community until a new church was constructed in 1970. Since Amherst is known as the "Sandstone Center of the World," the church was appropriately constructed of native sandstone. St. Joseph's Church is located at 200 St. Joseph Drive. (Bill Jackson.)

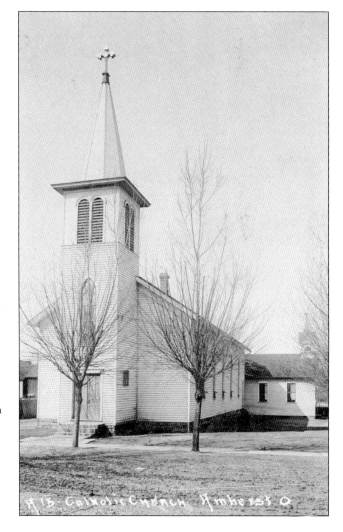

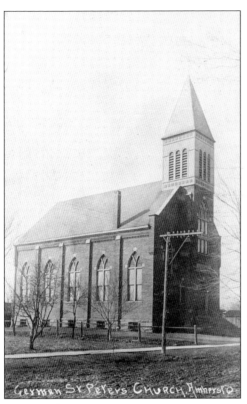

GERMAN ST PETER'S CHURCH, AMHERST.
St. Peter's United Church of Christ was established in 1857 by a group of German immigrants who had settled in Black River and Amherst Townships. A second church was built in 1892 to accommodate the growing congregation. A steel bell, cast in Sheffield, England, was placed in the old church in 1860. This bell continues to call people to worship today. The church is at 582 Church Street and looks much as it did when this photograph was taken. (Bill Jackson.)

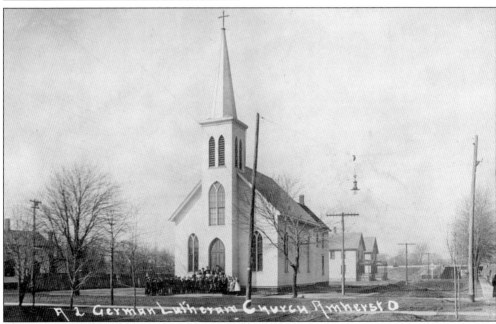

GERMAN LUTHERAN CHURCH, AMHERST (A2). St. Paul's Evangelical Lutheran Church has been serving the Amherst community since it was founded as a German congregation in 1875. A new church, designed by architect Granville E. Scott, was dedicated in 1954, and replaced the original church shown here. It is located at 115 Central Drive. (Paula Brosky-Shorf.)

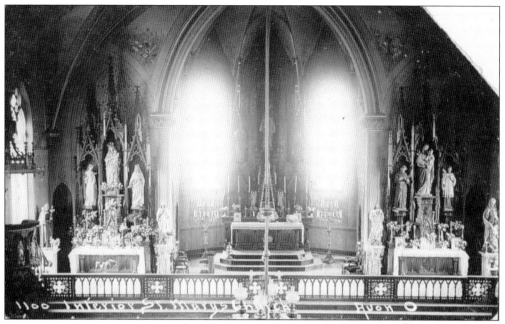

INTERIOR ST. MARYS CHURCH, AVON (1100). The original St. Mary's Church was formed by immigrant German farmers who built a frame house of worship in 1849. A new St. Mary's Church, shown here, was built in 1895. It was considered one of the most finely appointed churches at the time it opened. (Bill Jackson.)

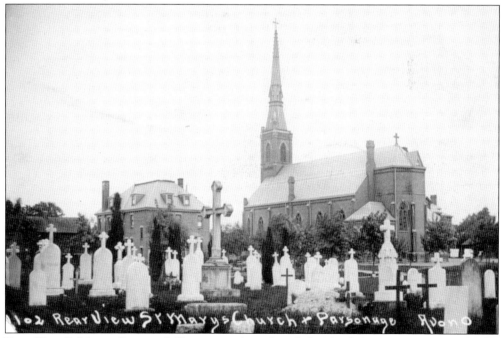

REAR VIEW ST MARYS CHURCH & PARSONAGE, AVON (1102). St. Mary's Parsonage, on Stoney Ridge Road at French Creek, had the first multiroom schoolhouse in Avon. (Paula Brosky-Shorf.)

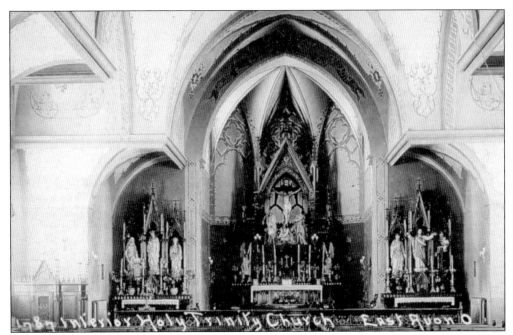

INTERIOR HOLY TRINITY CHURCH, EAST AVON (1787). Located at Detroit and Nagel Roads, this church was built starting in 1900, and its first Mass was held in 1902. Built of Westlake- and Amherst-quarried sandstone, the church was promptly repaired after it was damaged in the 1924 tornado. A new cemetery and rectory were also completed at the time. (Bill Jackson.)

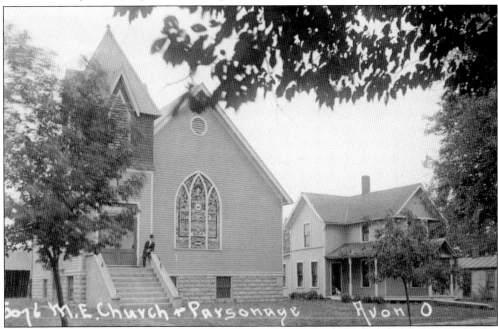

M.E. CHURCH & PARSONAGE, AVON (5076). Built in 1911 on Detroit Road to replace the prior church that burned, the Methodist Episcopal church was completed in one year. A new Methodist church was built in 1964 at a new location, and this church building is now the Church of God-Pentecostal. (Paula Brosky-Shorf.)

INTERIOR M.E. CHURCH, ELYRIA (A506).
An interior view of the Elyria Methodist
church shows its altar, choir section, and
pipe organ. The church is a Late Gothic
Revival–style building. (Paula Brosky-Shorf.)

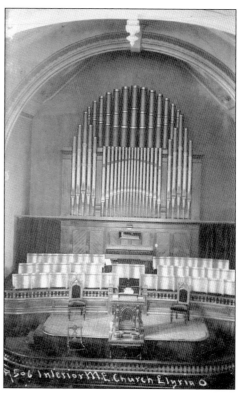

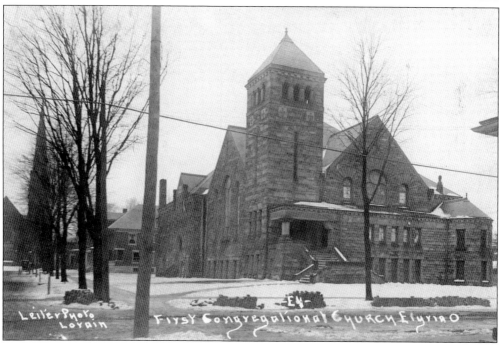

FIRST CONGREGATIONAL CHURCH, ELYRIA (E4). Built in 1898, the First Congregational Church
replaced the former 1848 Presbyterian church on this site that had been torn down. Located on the
town square at Second Street, the formidable structure is built of sandstone. (Paula Brosky-Shorf.)

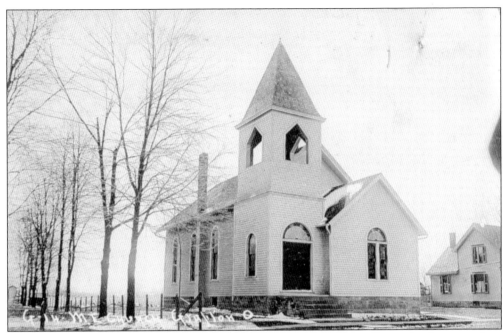

M.E. Church, Grafton (G14). The Methodist church at Rawsonville, as Grafton was then called, was organized in March 1871. After the original structure burned in 1874, work on the new building was promptly begun. The sanctuary of the new church was dedicated on January 14, 1875. An addition was made in 1894, and the sanctuary was remodeled in 1912. In 1962, an extensive addition was made. (Bill Jackson.)

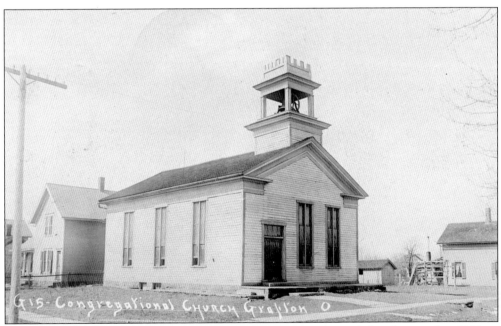

Congregational Church, Grafton (G15). The First Congregational church opened in 1855 on Oak Street, and the congregation was dissolved in 1928. (Paula Brosky-Shorf.)

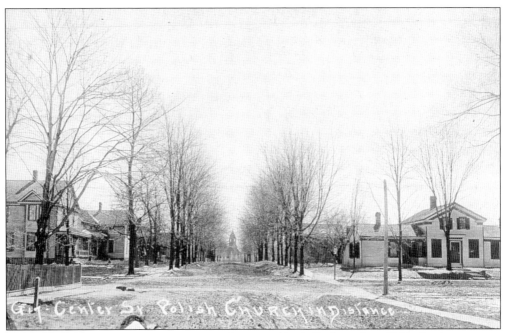

CENTER ST POLISH CHURCH IN DISTANCE, GRAFTON (G17). Dedicated in 1894, the Assumption Catholic Church was the second Catholic church built in Grafton in answer to the petition of 75 Polish families to have their own place of worship. The first Catholic church, Immaculate Conception, merged with Assumption Parish to become Our Lady Queen of Peace. Fr. John P. Seabold was appointed pastor of the new church in 2006. (Bill Jackson.)

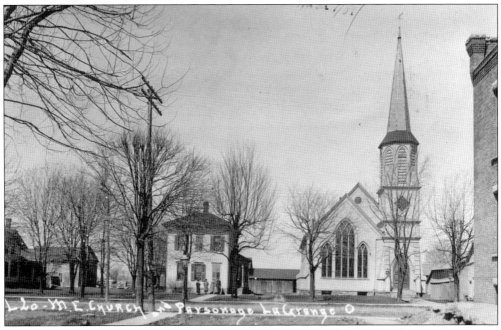

M.E. CHURCH AND PARSONAGE, LAGRANGE (L20). The first Methodist church in LaGrange was organized in 1833. It was destroyed by fire in 1867. After the congregation reorganized, a new church and the parsonage next door was built in 1874. The church is still active today. (Paula Brosky-Shorf.)

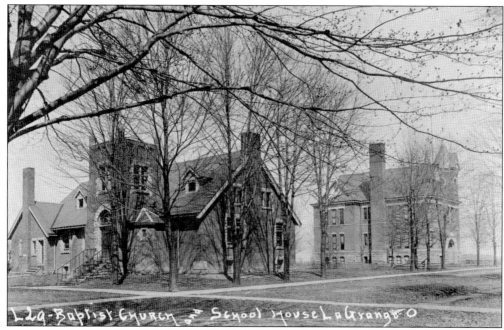

BAPTIST CHURCH AND SCHOOL HOUSE, LAGRANGE (L29). To fulfill a promise of preaching in LaGrange for 10 years in exchange for 50 acres of land, Rev. Julius Beeman organized the First Baptist Church in 1828. The current church, shown here, was built in 1896 on Church Street. (Paula Brosky-Shorf.)

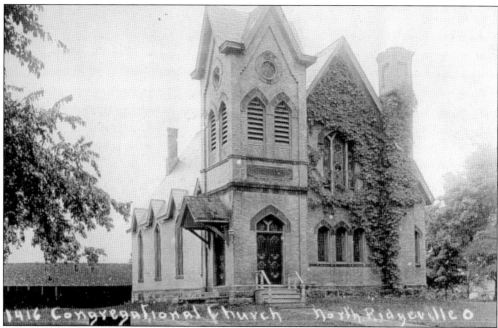

CONGREGATIONAL CHURCH, NORTH RIDGEVILLE (1416). Formed in 1822, this church was originally the property of a Presbyterian denomination. After the direction of the original congregation changed around 1840, it became a United Church of Christ Congregational. The church building is still in use, and in 2022 celebrated its 200th anniversary. (Bill Jackson.)

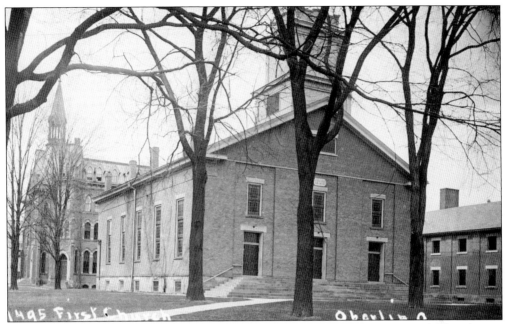

FIRST CHURCH, OBERLIN (A495). First Church, originally First Congregational Church, was constructed in 1842. It was used for church services, public college exercises, and town meetings. It was the home church for the Oberlin community from 1843 to 1860. In 1908 and again in 1927, extensive repairs were made to the building. (Bill Jackson.)

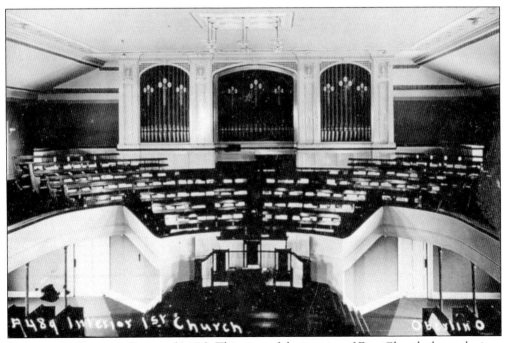

INTERIOR 1ST CHURCH, OBERLIN (A489). This view of the interior of First Church shows the iron posts that replaced the thick Doric columns supporting the balcony in 1892. The iron posts were removed sometime before 1927 when the pulpit and organ loft were redesigned. (Bill Jackson.)

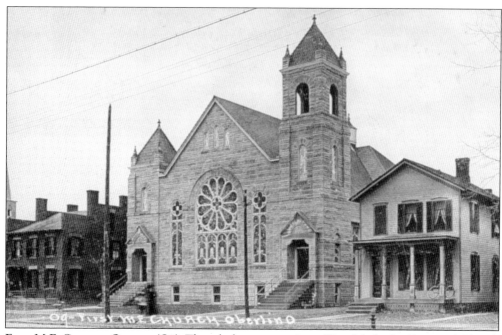

FIRST M.E. CHURCH, OBERLIN (O9). Though the congregation of First Methodist Episcopal Church was formed in the 1830s by a Methodist circuit rider, it was not until December 1869 that building a church in Oberlin was proposed. Dedicated in 1873, this building served as the Methodist Episcopal church until 1906, when a large stone structure on North Main Street was built to replace it. This church burned in 1917. The Methodists worshiped in various locations before moving into their current building, which was dedicated January 1, 1928. (Bill Jackson.)

2ND CONGREGATIONAL CHURCH, OBERLIN (O14). In 1860, a separate congregation was formed by 103 members of First Church, and in 1870, Second Church was ready for worship. It was a large Gothic structure on West College Street. In 1900, the First and Second Congregational Churches combined. First Church was remodeled, and services for Oberlin's Congregationalists were held there. In 1927, the college purchased the property, removed the steeple, and remodeled the building as a temporary home for the Department of Zoology. The building was demolished in August 1959. (Bill Jackson.)

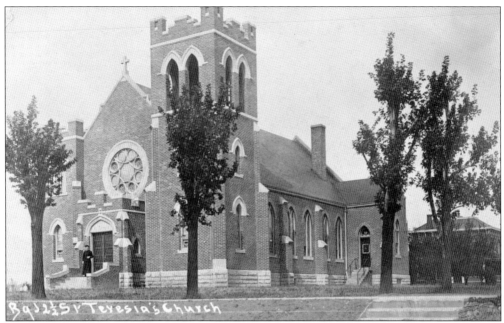

ST. TERESIA'S CHURCH, SHEFFIELD (B962½). In 1842, German Catholic settlers in Sheffield petitioned the Diocese of Cincinnati for the services of a priest. In 1845, a log church was replaced by a frame church that burned in 1907. The current church was built the same year. (Paula Brosky-Shorf.)

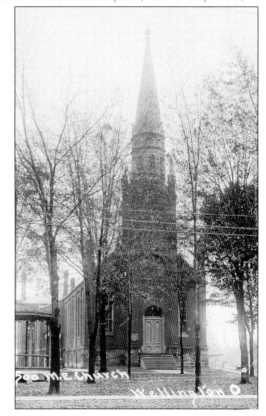

M.E. CHURCH, WELLINGTON (500). On December 19, 1866, the Methodist congregation in Wellington made the commitment to build a new church. Six months later, the foundation was under construction. Large quantities of stone from the Berea quarries were delivered, and masonry work commenced. The new church was dedicated December 25, 1867. (Bill Jackson.)

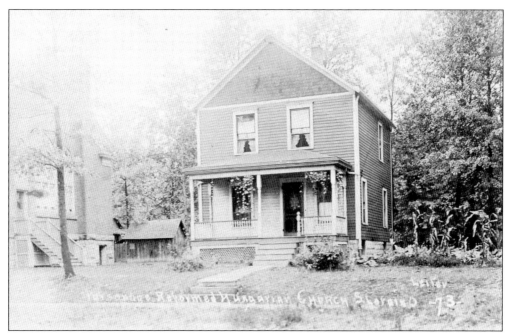

PARSONAGE REFORMED HUNGARIAN CHURCH, S. LORAIN (73). The Reformed Hungarian Church in Lorain was organized on September 7, 1902, by 74 members led by Andrew Estenes. Rev. Bela Basso was the first pastor. The church was dedicated in 1904, followed by the construction of a parsonage in 1906. The parsonage was replaced in 1927. (Bill Jackson.)

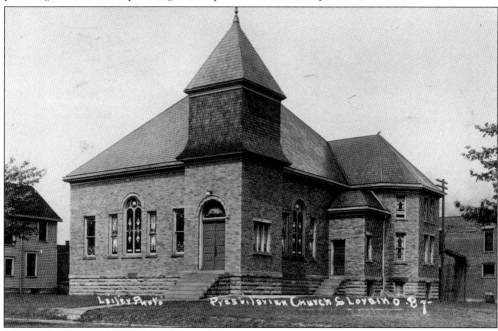

PRESBITERIAN CHURCH, S LORAIN (87). The First Presbyterian Church in Lorain was dedicated in 1900 at 1895 East Thirtieth Street. In 1912, Rev. A.C. Thompson began serving as its pastor. This house of worship was an integral part of the South Lorain neighborhood for 117 years before its closing in 2017. (Paula Brosky-Shorf.)

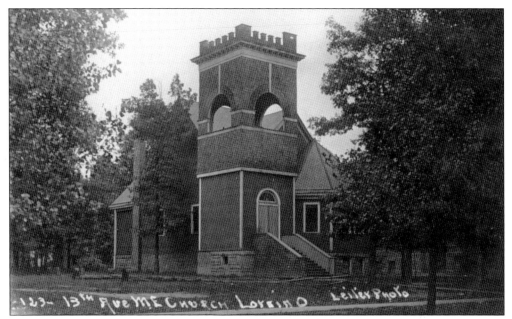

13TH AVE M.E. CHURCH, LORAIN (123). Organized on July 13, 1900, with 57 members, this congregation was originally named South Lorain Methodist Church, on Thirteenth Avenue between Seneca and Pearl Streets. A few years later, the name was changed to the Thirteenth Avenue Methodist Episcopal Church. When Thirteenth Avenue became East Thirty-first Street in 1909, the name was changed to Grace Methodist Episcopal Church, at 1827 East Thirty-first Street. (Bill Jackson.)

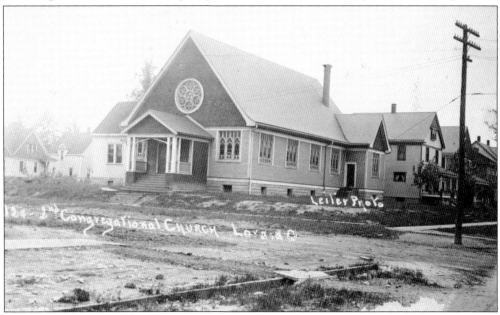

2ND CONGREGATIONAL CHURCH, LORAIN (124). The Second Congregational Church was organized in February 1896 with 14 members. In 1905, it was called South Lorain Congregational, located at Fourteenth Avenue and Pearl Street. Rev. Walter Spooner was the pastor. After the street names changed in 1909, the church was known as Second Congregational, at 3230 Pearl Avenue. It is no longer in existence. (Paula Brosky-Shorf.)

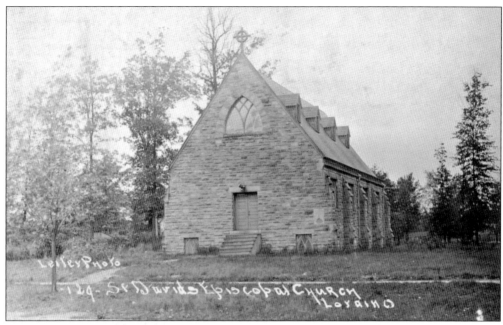

St Davids Episcopal Church, Lorain (129). This stone church was built in the 1890s on what is now East Thirty-first Street. The building has been home to several congregations and today is a day care center. (Bill Jackson.)

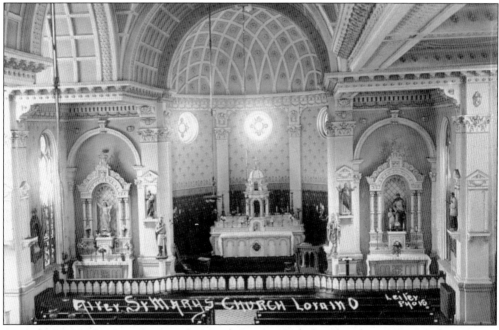

Alter St Marys Church, Lorain. St. Mary's Roman Catholic Church was organized in 1873 as St. Mary of the Lake. The first church was built of wood and dedicated in 1880. After the church was destroyed by fire in 1895, a new brick edifice was built. The 1924 tornado damaged the church, and it was replaced by the current stone structure. The church is located at 309 West Seventh Street. (Bill Jackson.)

CONGREGATIONAL CHURCH, LORAIN. The First Congregational Church was organized in Lorain in 1872 by Rev. A.D. Barber. The cornerstone of the church, located at Fourth Street and Washington Avenue, was laid in 1878. The church was heavily damaged by the 1924 tornado; the steeple fell east onto the fire station next door. A new church was built on the same lot. (Paula Brosky-Shorf.)

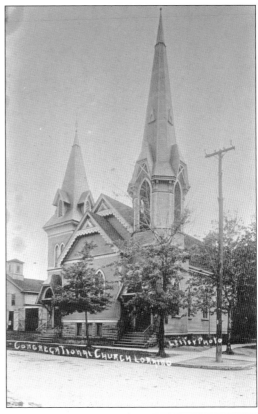

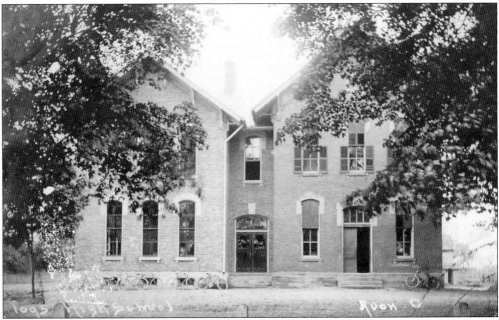

HIGH SCHOOL, AVON (1095). Julian Street School, the structure on the right, was built in 1880. In 1903, the addition on the left was built to house high school students. The school is remembered today by the date plaque that was rescued and placed at the village school. (Bill Jackson.)

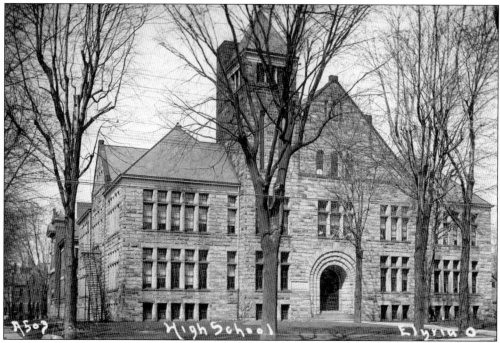

HIGH SCHOOL, ELYRIA (A503). The Elyria High School Washington building was built and opened in 1894. When a new high school was built, the Washington building was totally renovated and incorporated into the new high school, preserving its unique architecture. (Paula Brosky-Shorf.)

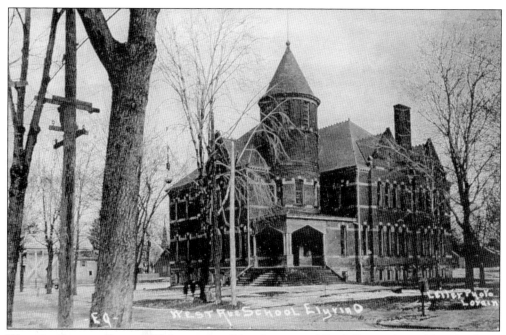

WEST AVE SCHOOL, ELYRIA (E9). Located on West Avenue and Sixth Street, this public school was first erected in 1883 and known as Franklin School. It burned in 1893 and was rebuilt and opened in 1894, as shown here. (Bill Jackson.)

CHESTNUT ST SCHOOL, GRAFTON (G13). The first school in Grafton opened in 1849 on the Rawson property near Willow Park and moved to Chestnut Street in 1868. The building was replaced in 1876. The building shown here was built to serve grades one through twelve. (Bill Jackson.)

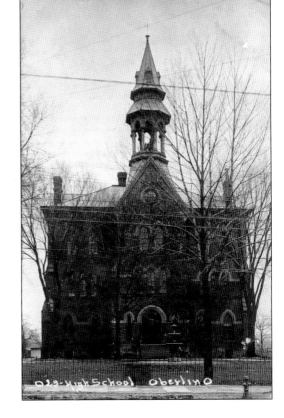

HIGH SCHOOL, OBERLIN (O23). In 1873, a bond issue was passed for a new Union School building to be erected on South Main Street. When it opened in November of the following year, the enrollment was 629. The new Gothic Revival–style school was built of sandstone and brick at a cost of $37,000, with the furniture costing an additional $3,500. The school served the village until 1923. (Bill Jackson.)

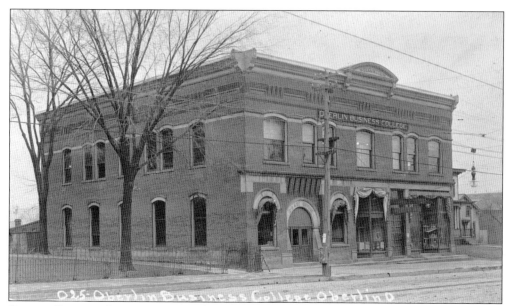

OBERLIN BUSINESS COLLEGE, OBERLIN (O25). In 1895, Oberlin Business College was chartered by the state. The school was in the Beckwith Block, shown here, which also housed the post office on the east side of South Main Street. In 1915, it was accredited to offer a two-year training course for business teachers. Oberlin Business College changed its name to Oberlin School of Commerce in 1926. (Bill Jackson.)

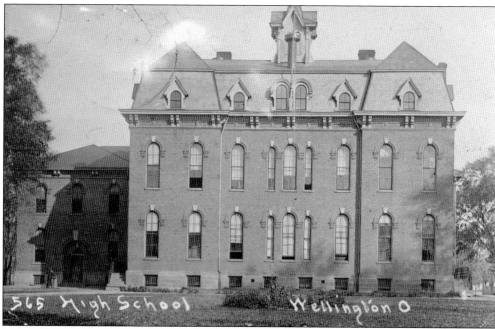

HIGH SCHOOL, WELLINGTON (565). Starting in 1867, the Union High School in Wellington was erected with Berea sandstone and 400,000 bricks. An addition was added 10 years later. The grand building was eventually swallowed up by many additions in the 20th century, rendering it unrecognizable. It became McCormick Middle School before being demolished in 2015. (Paula Brosky-Shorf.)

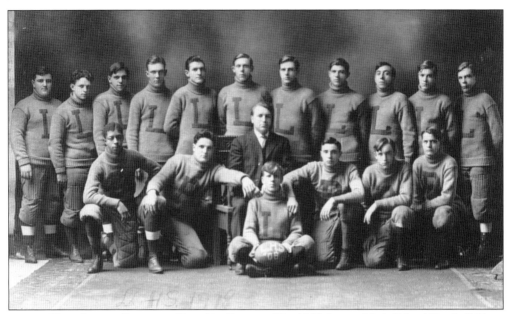

LORAIN HIGH SCHOOL FOOTBALL TEAM '08, LORAIN. The 1908 Lorain High School Football Team was housed in the old Union School on the southwest corner of Sixth Street and Washington Avenue. A larger school was needed, and construction started in 1910 on a new building at the same site. Hamilton E. Ford was the architect. By 1913, the new Lorain High School was opened. It served the community until 1995 and was demolished in 2010. (Paula Brosky-Shorf.)

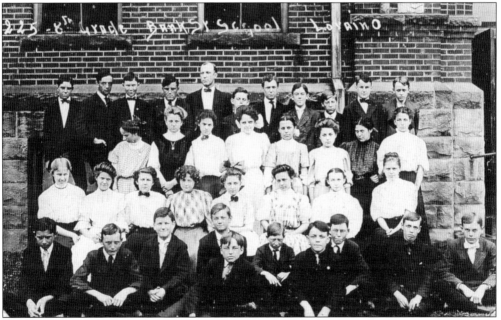

8TH GRADE BANK ST SCHOOL, LORAIN (225). Bank Street School was built in 1899 at Bank Street near Washington Avenue. In 1909, Hannah E. Burrett was the principal. When the street names were changed in 1909, the address became 1033 Sixth Street, and the school was renamed Charleston School, in honor of the original name of Lorain. The building was completely destroyed in the 1924 tornado, but parts were salvaged for the board of education's new building. (Bill Jackson.)

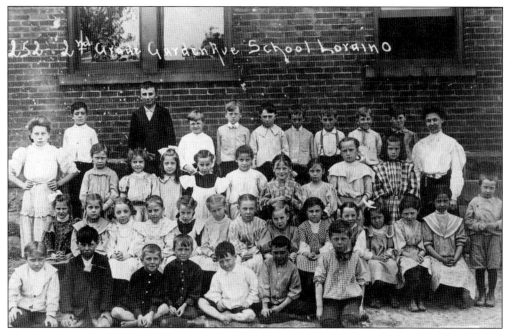

2ND GRADE GARDEN AVE SCHOOL, LORAIN (252). Garden Avenue School was opened in 1890 at 1852 Garden Avenue between Nineteenth and Twentieth Streets. In 1912, Abbie Reid was the principal. She was one of three students to graduate in the first class of Lorain High School. Garden Avenue School was demolished in 1938 to make room for Boone School. (Paula Brosky-Shorf.)

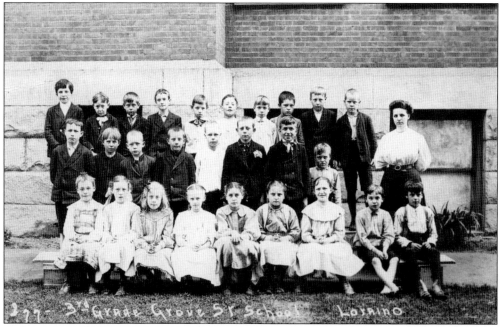

3RD GRADE GROVE ST SCHOOL, LORAIN (277). Grove Street School, also known as Oakwood School, opened in 1905 at what is now Grove Avenue and East Thirty-first Street in South Lorain, directly across from Oakwood Park. R.B. Faris was the first principal. The school was demolished in 1971 to make room for the new Lorain Fire Department Station No. 3. (Paula Brosky-Shorf.)

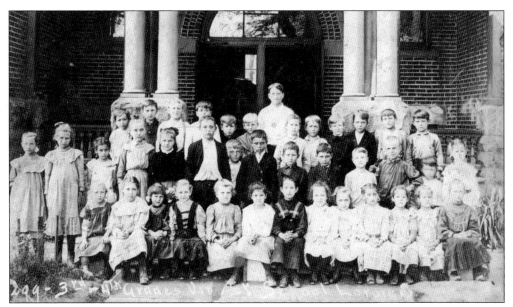

3RD & 4TH GRADES VINE ST SCHOOL, LORAIN (299). Vine Street School was opened in 1904 at the corner of what is now Vine Avenue and East Thirty-first Street. The steel industry in South Lorain was growing, as were the number of school-age children in the area. It was later renamed Lincoln School. In 1967, a new school was built directly across East Thirty-first Street. Lincoln School closed in 2005, and the schoolhouse became the Lincoln Community Center. The building was demolished in 2008. (Paula Brosky-Shorf.)

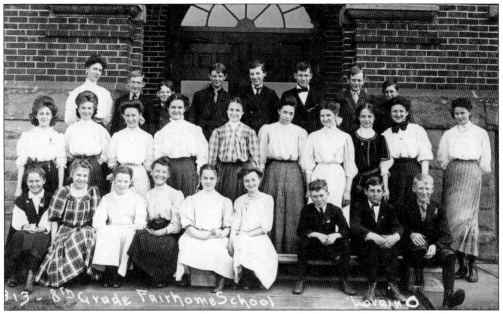

8TH GRADE FAIRHOME SCHOOL, LORAIN (313). Fairhome School was built in 1901 on Idaho Avenue. A fire in December 1920 destroyed much of the first floor. The building was also damaged in 1924 by the deadly Lorain tornado. In 1952, a new Fairhome Elementary School opened; it closed in 1995. In the years that followed, the building was home to several educational programs. By 2007, it was vacant. (Paula Brosky-Shorf.)

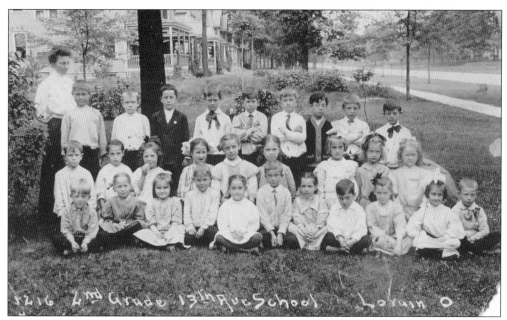

2ND GRADE 13TH AVE SCHOOL, LORAIN (1216). Thirteenth Avenue School was built in 1896 on Thirteenth Avenue. When the streets were renamed in 1909, the new address became East Thirty-first Street, near Pearl Avenue. It was renamed Lowell School in honor of James Russell Lowell, one of the noted New England fireside poets. The building was closed in 1961, and students were relocated to the new Lowell School on Clinton Avenue in South Lorain. (Paula Brosky-Shorf.)

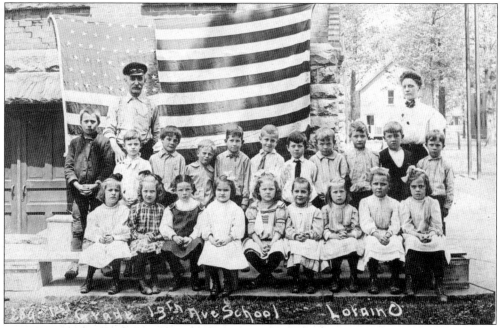

1ST GRADE 13TH AVE SCHOOL, LORAIN (289). Thirteenth Avenue School was built in South Lorain in 1896. The name was changed to Lowell School when the streets were renamed in 1909. At that time, Andrew O. Fleming was the principal. A man in military uniform is seen standing behind the students, with a large flag in the background. (Paula Brosky-Shorf.)

Five

OBERLIN COLLEGE

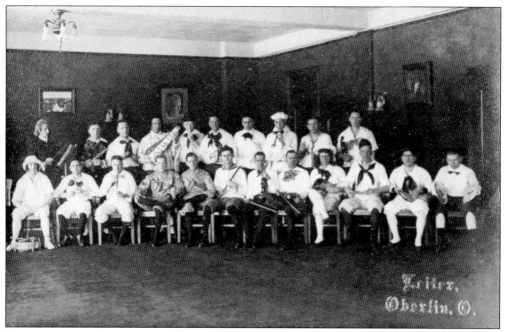

MUSICAL GROUP, OBERLIN COLLEGE, OBERLIN. This photograph shows what appears to be a Baroque musical ensemble, with instruments that include a lute, violins, and wooden flutes (recorders). Today, the Oberlin Conservatory of Music sponsors approximately 500 concerts on campus each year. This includes recitals and concerts by the more than 25 student ensembles and performances and master classes by guest artists. Faculty members perform on campus and throughout the world. Oberlin's Artist Recital Series featured concerts by a range of acclaimed artists. (Bill Jackson.)

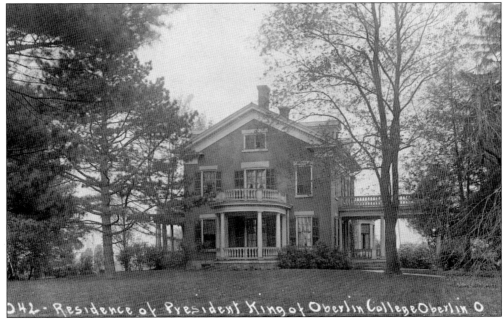

RESIDENCE OF PRESIDENT KING OF OBERLIN COLLEGE, OBERLIN (O42). This Greek Revival–style home at 315 East College Street was originally the home of Jabez Lyman Burrell, who built it in 1852 and gifted it, along with the land, to Oberlin College. The college sold it to Henry King when he became president. The home is listed in the National Register of Historic Places. (Paula Brosky-Shorf.)

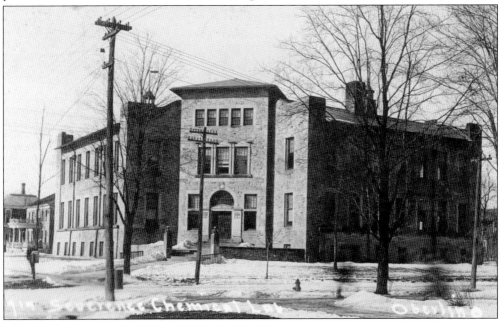

SEVERENCE CHEMICAL LAB, OBERLIN (714). Severance Chemical Laboratory was a gift of Louis H. Severance of Cleveland. After completion of construction, which began in 1899, the building was dedicated on September 26, 1901. Severance Hall, as it is called now, is constructed of Ohio sandstone and is located at the northwest corner of Lorain and Professor Streets. It was designated a city landmark in September 1975. (Paula Brosky-Shorf.)

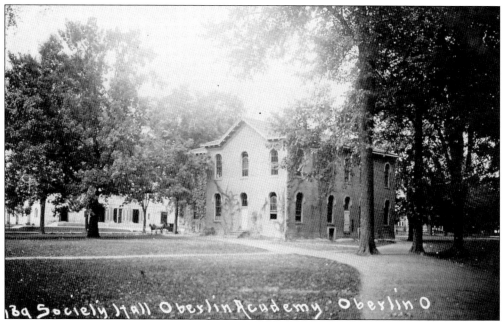

SOCIETY HALL OBERLIN ACADEMY, OBERLIN (1789). Construction of Society Hall began in 1867 and was completed in 1868. The first floor contained three lecture rooms; the second floor housed libraries and a "society room," from which the building took its name. Society Hall was torn down in accordance with the plan to clear the central campus on Tappan Square. (Paula Brosky-Shorf.)

DASCOMB COTTAGE, OBERLIN COLLEGE, OBERLIN (1731). Dascomb Cottage on West College Street between North Professor and North Cedar Streets was formerly a private residence. This grand Queen Anne mansion was named for its prior residents, Marianne P. Dascomb, the first head of Oberlin's women's department, and her husband, Dr. James Dascomb, the first doctor in Oberlin. It opened as a women's dormitory in 1907 and was demolished in 1954. (Bill Jackson.)

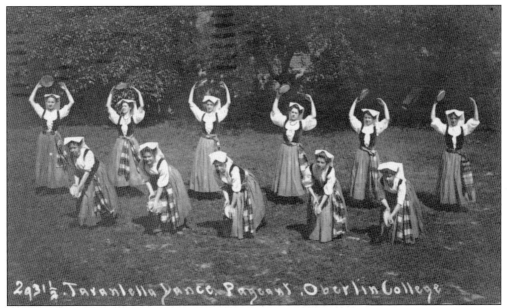

TARANTELLA DANCE PAGEANT, OBERLIN COLLEGE, OBERLIN (2931½). In 1885, Oberlin College hired Delphine Hanna as the first woman professor of physical education in the United States. Professor Hanna's innovations included not just making movement part of the curriculum but calling it dancing. Inside the classroom, the students developed a strong scientific basis of technique. They put on yearly pageants that were performed to classical music or other genres and often had natural or historical themes. Hundreds of students were involved in these pageants. (Paula Brosky-Shorf.)

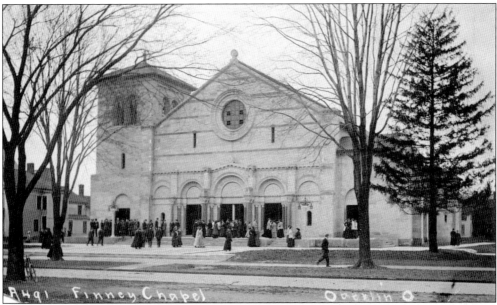

FINNEY CHAPEL, OBERLIN (A491). In 1903, Oberlin president Henry King worked with Frederick Finney, former president Charles Grandison Finney's son, to construct a new chapel in President Finney's honor. The design by architect Cass Gilbert is an interpretation of the Romanesque of Southern France. The chapel was built on the site of Finney's former home at Lorain and Professor Streets and was dedicated on June 21, 1908, as part of the college's 75th anniversary. (Bruce L. Waterhouse Jr.)

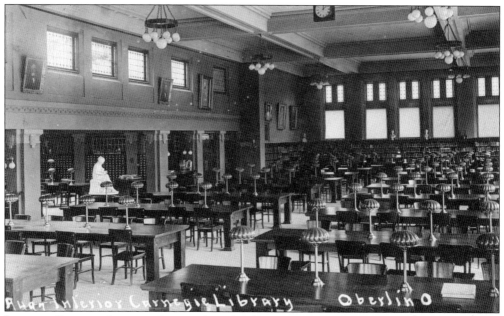

INTERIOR CARNEGIE LIBRARY, OBERLIN (A497). The Carnegie library, gifted by Andrew Carnegie, is at the northeast corner of Professor and Lorain Streets. The building was dedicated June 23, 1908. The first floor was designed with three rooms for special classes of readers, a cloak room, three work rooms, and a faculty room. The second floor contained the large reading room that accommodated 284 readers. The third and fourth floors were the seminar rooms. Adjoining all floors was the stack room, six stories in height. (Bill Jackson.)

BALDWIN HALL, OBERLIN COLLEGE, OBERLIN (O _ _ _ ½). Baldwin Hall was constructed around 1886 of rough, unfinished golden sandstone in a style known as organic irregularity. This dormitory, complete with a piano lounge and plenty of places for study, was a popular place to live on campus. The building is currently the home of the Women and Trans Collective. (Paula Brosky-Shorf.)

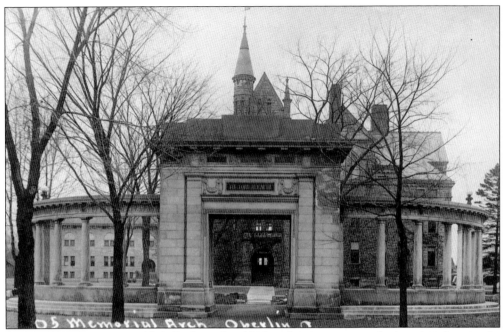

MEMORIAL ARCH, OBERLIN (O5). Dedicated in 1903 to the missionaries who lost their lives in the Boxer Rebellion, the arch dominates the east path that bisects Tappan Square. Its light-colored limestone construction makes a prominent campus entrance from the west. (Bill Jackson.)

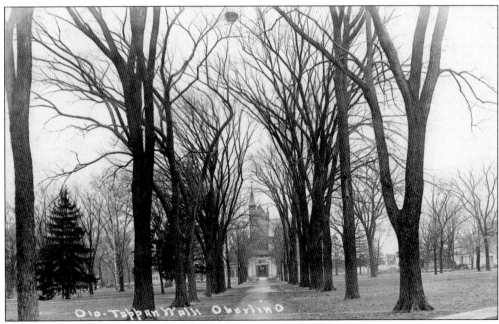

TAPPAN WALK, OBERLIN (O10). This view is from the center of Tappan Square in Oberlin, looking west to the Memorial Arch and Peters Hall. (Bruce L. Waterhouse Jr.)

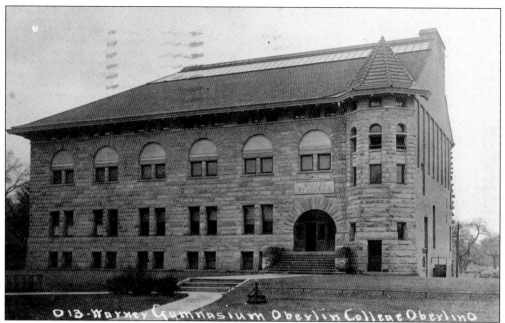

WARNER GYMNASIUM, OBERLIN COLLEGE, OBERLIN (O13). Ground was broken for Warner Gymnasium, built of Ohio sandstone, in August 1900, and the building was completed in the fall of 1901. It was named in honor of its donors, Dr. Lucien C. Warner and his wife, Karen, of New York, who provided funds for the building together with an endowment fund. Later, the Warners also contributed funds for an addition to the gymnasium. (Bill Jackson.)

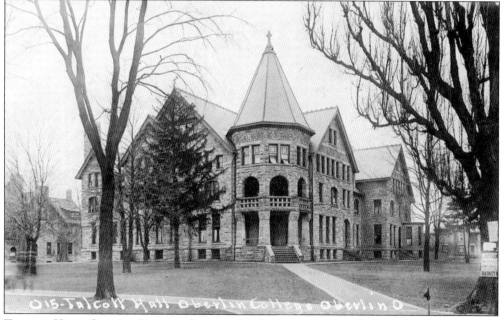

TALCOTT HALL, OBERLIN COLLEGE, OBERLIN (O15). Another college building finished in rough-cut golden sandstone, Talcott Hall was erected in 1886, replacing the Second Ladies Hall after a fire. The first floor is a study/lounge, and the second and third floors were student rooms. The 10 gables are dominated by the three-story tower with two stories of open porches. (Bill Jackson.)

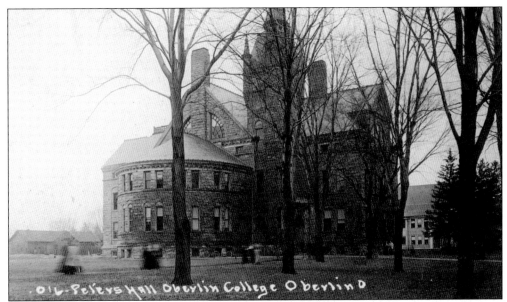

PETERS HALL, OBERLIN COLLEGE, OBERLIN (O16). Peters Hall is a survivor. Dedicated in 1887, the building survived several attempts at demolition and was finally completely renovated in 1997. It was the first campus building to have forced air heating and ventilation. A two-story central court, auditorium, lecture rooms for physics and astronomy, and offices filled the three-story building. As part of its new international identity in 1997, it housed the modern language departments, other international offices, and the Shansi Memorial Association. (Bill Jackson.)

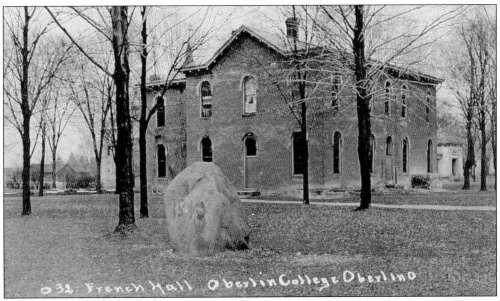

FRENCH HALL, OBERLIN COLLEGE, OBERLIN (O32). French Hall was finished in 1868. It was a two-story brick building on the west side of Tappan Square. French Hall contained three recitation rooms on the first floor. On the second floor, students received instruction in drawing, painting, and natural philosophy. In 1887, when Peters Hall was completed, French Hall was used for recitation purposes. It was torn down in 1927 in accordance with a contract with the Trustees of the Hall Estate to clear Tappan Square of all buildings. (Bill Jackson.)

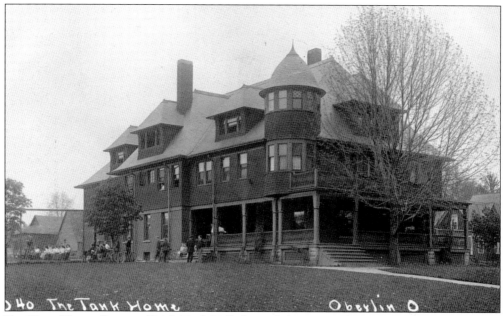

THE TANK HOME, OBERLIN (O40). Tank Hall, formerly known as the Tank Home, was erected in 1896 as a home for children of missionaries of the American Board of Commissioners for Foreign Missions. For 10 years, from 1922 to 1932, and then again after 1935, it was used as a residence hall for women, with accommodations for 44 students. Today, Tank houses approximately 40 students, chosen by random lottery each year. (Paula Brosky-Shorf.)

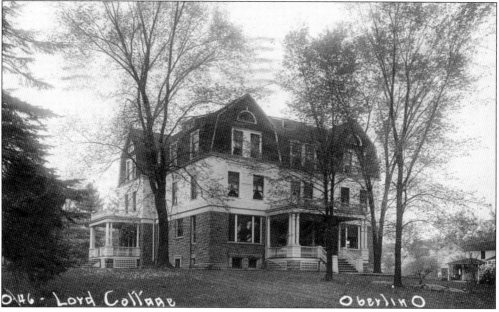

LORD COTTAGE, OBERLIN (O46). Lord Cottage, named for its principal donor, Elizabeth W.R. Lord, originally provided dormitory accommodations for 40 women. The builder, Adam Feick and Brothers of Sandusky, Ohio, were employed by the college for a number of other buildings on campus. The first story was constructed of brown stone, and the second and third floors were in wood. It was demolished around 1965. (Bruce L. Waterhouse Jr.)

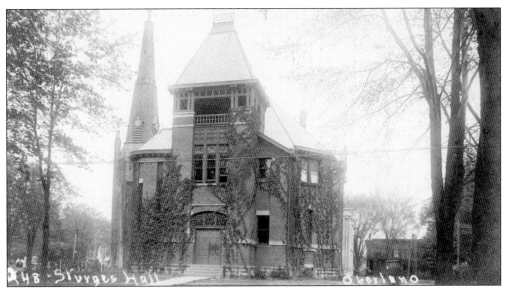

STURGES HALL, OBERLIN (O48). Sturges Hall was built in 1884 next to the Soldier's Monument. It was used primarily as an assembly room for college women, but since 1907, its assembly room was used for lecture and recitation for large classes in the College of Arts and Sciences. The building was named for Susan M. Sturges, the principal donor. Sturges Hall was remodeled in 1952 but then demolished in 1963 to make way for new conservatory buildings. (Bill Jackson.)

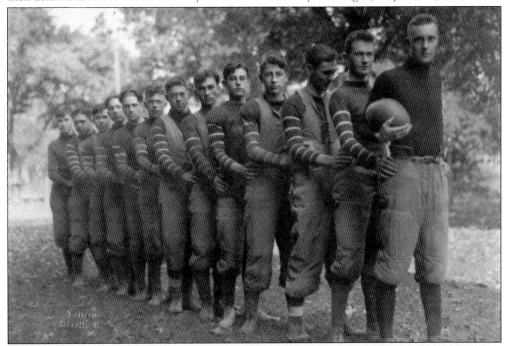

OBERLIN COLLEGE FOOTBALL TEAM, OBERLIN. The Oberlin varsity football team was part of the Ohio Athletic Conference, which included Case School of Applied Science, Kenyon College, Ohio State University, Western Reserve College, Heidelburg University, Denison University, and the College of Wooster. The team's games against Case in Cleveland were popular, and large numbers of Oberlin students and residents rode chartered interurban cars to attend. (Paula Brosky-Shorf.)

Six

COMMUNITY EVENTS AND 103RD OHIO VOLUNTEER INFANTRY

COTTAGES AT CAMP 103RD O.V.I., LORAIN (1541). Many new cottages, along with a new barracks, were built between 1909 and 1910. The cottages have been in use for over 100 years. The large trees and landscaping make for an idyllic spot. (Paula Brosky-Shorf.)

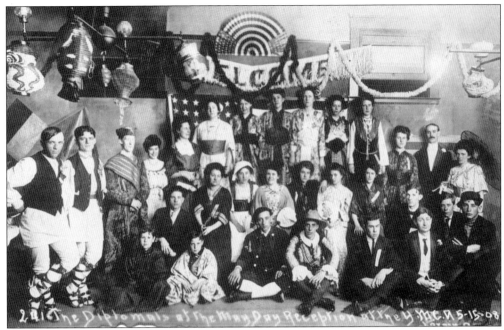

THE DIPLOMATS AT THE MAY DAY RECEPTION AT THE Y.M.C.A. 5-15-08, LORAIN (241). The Lorain YMCA was home to many celebrations and programs in the early 1900s. The building, built in 1899, was on East Twenty-eighth Street in Lorain. In 1923, a new building was erected on the site after a fire. (Paula Brosky-Shorf.)

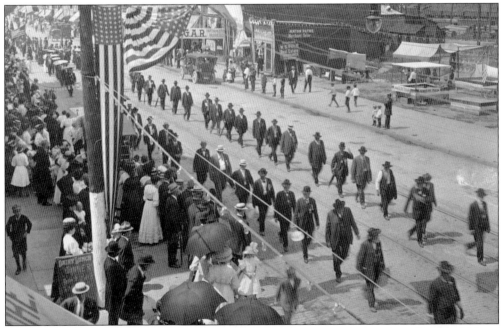

GRAND ARMY OF THE REPUBLIC PARADE JUNE 11 1911, LORAIN. A crowd estimated at 80,000 lines Broadway Avenue to watch the parade of Civil War veterans from all over Ohio on June 11, 1911, 46 years after the end of the war. Ohio had about 770 Grand Army of the Republic posts across the state, and a large number of them were represented here. (Paula Brosky-Shorf.)

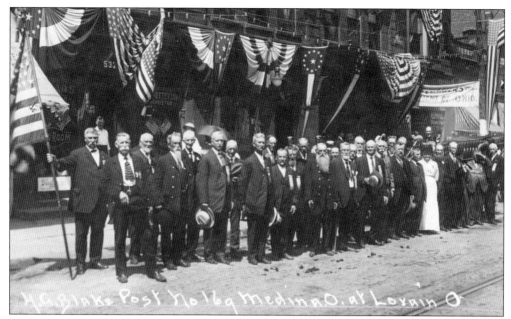

H.G. Blake Post No 169 Medina O. at Lorain (GAR June 1911), Lorain. Positioned at the headquarters of the Ohio GAR encampment at Fifth Street and Broadway Avenue, Post No. 169 forms a proud line. The post was named in honor of Col. H.G. Blake, who led the 166th Ohio Volunteer Infantry during the war. His home, a stop on the Underground Railroad, has been lovingly restored as a living museum in Medina. (Paula Brosky-Shorf.)

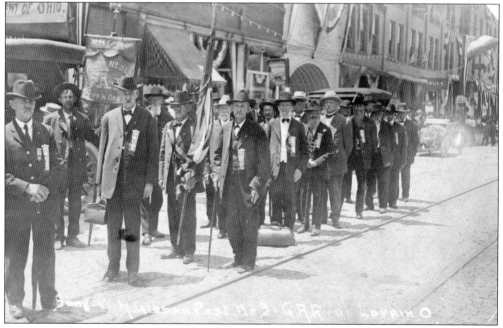

W.H. Gibson Post No. 31 G.A.R. at Lorain O (GAR June 1911) (5006), Lorain. The post's namesake, Col. William Harvey Gibson (1821–1894), 49th Ohio Infantry, was known as the "silver-tongued orator." Here, veterans from Tiffin, Ohio, GAR Post No. 31 pose at the GAR headquarters on Broadway Avenue. (Paula Brosky-Shorf.)

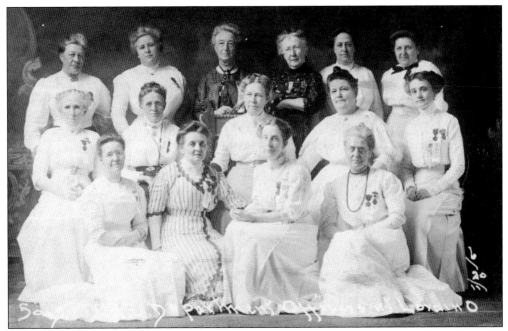

W.R.C. Department Officers at Lorain 6/20/11 (5003). The Women's Relief Corps was founded in 1883 as the official women's auxiliary to the Grand Army of the Republic. Its primary purpose is to preserve the memory of the GAR, a veterans' advocacy organization for Union soldiers of the Civil War. The corps is still active today, although its members have been greatly reduced in number. This photograph was taken during the June 20, 1911, GAR encampment at Lorain. (Paula Brosky-Shorf.)

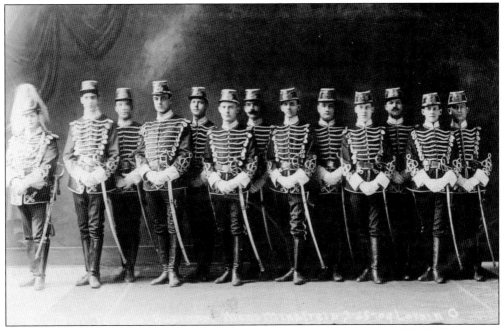

Drill Team Business Mens Minstrels 3-25-09, Lorain. The Lorain Business Men's Club met on the first Friday of each month in the Clark Block at 312 Broadway Avenue. In 1909, F.C. La Marche was president, E.F. Resek was secretary, and George Clark was treasurer. (Paula Brosky-Shorf.)

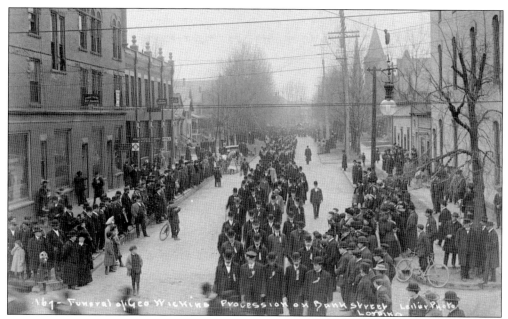

Funeral of Geo Wickins Procession on Bank Street, Lorain (167). Former Lorain mayor George Wickens died suddenly on March 19, 1908. He was born in England in 1852 and made Lorain his home in 1871. He was a successful furniture dealer and undertaker. In 1903, he built the Parkside Funeral Chapel next to his home on West Erie Avenue. This photograph faces west down what would later be renamed Sixth Street. Note the signs on the building on the left: Dr. W.F. Dager, Dr. McNamara, Dr. Hinman, Frank Floding Real Estate, and Wells Fargo and Company Express. (Paula Brosky-Shorf.)

Decoration Day Parade 5-31-09, Lorain (1174). The first official Decoration Day, May 30, 1868, at Arlington Cemetery, honored the graves of the Civil War veterans buried there. By 1890, it had become a national holiday. In this 1909 view of the Lorain parade on Broadway Avenue, it was still dedicated to Civil War dead. (Paula Brosky-Shorf.)

THE LAUNCHING PARTY, LORAIN (5219). Guests of the American Ship Building Company are treated to a train ride at the launching of a new vessel. The launching of a new boat was always a grand, spectacular event, with owners, builders, and city residents in attendance. (Paula Brosky-Shorf.)

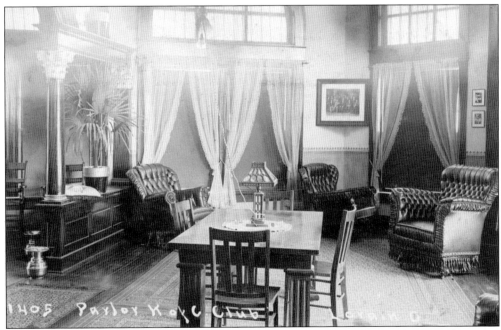

PARLOR K OF C CLUB, LORAIN (1405). The Knights of Columbus James L. Martin Council No. 637, Lorain, Ohio, began on January 19, 1902. The council used the fourth floor of the Lorain Block for meetings, as well as rest and recreation. (Paula Brosky-Shorf.)

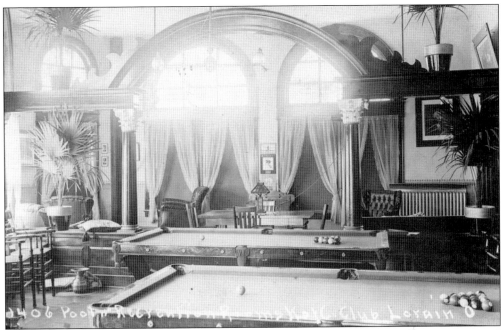

POOL & RECREATION ROOMS K OF C, LORAIN (1406). This view of the Knights of Columbus hall on the fourth floor of the Lorain Block shows the facilities before the tornado of June 28, 1924, wiped them out. The knights continued to meet in the reconstructed building until moving to their new building on Oberlin Avenue in 1968. (Paula Brosky-Shorf.)

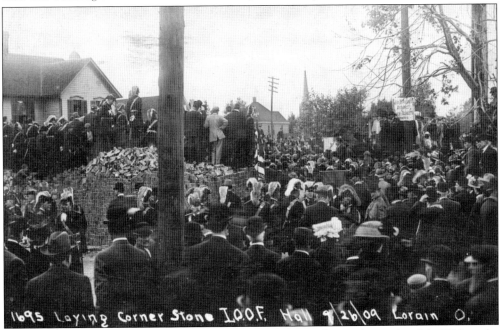

LAYING CORNER STONE I.O.O.F. HALL 9/26/09, LORAIN (1695). It is September 26, 1909, and a crowd is gathered at what would become 200 West Ninth Street, the Independent Order of Odd Fellows Hall, in Lorain. The occasion was the laying of the building's cornerstone, the start of construction that was completed a year later. (Paula Brosky-Shorf.)

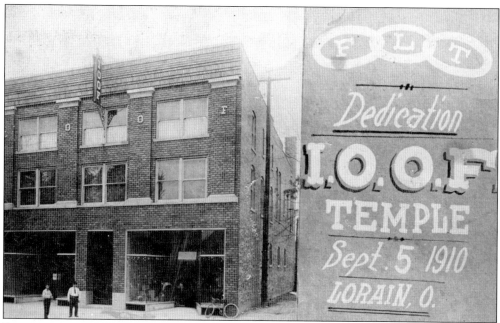

DEDICATION I.O.O.F. HALL SEPT. 5, 1910, LORAIN. Dedicated on September 5, 1910, the Lorain IOOF Hall stands today at 200 West Ninth Street in pristine condition, in the historic register as the American Felsol Company Building. American Felsol was a patent medicine manufacturer in Lorain in the 1930s. (Paula Brosky-Shorf.)

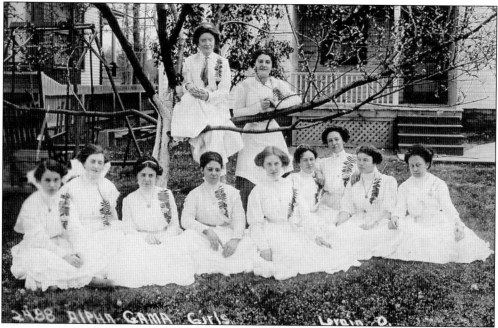

ALPHA GAMA GIRLS, LORAIN, (2488). Alpha Gamma Delta is an international women's fraternity, founded in 1904 at Syracuse University in New York. Its focus is on providing social, academic, and community service opportunities to both collegiate members and alumnae. Today, the organization has over 200,000 members. Its vision statement is "Inspire a Woman, Impact the World." (Bill Jackson.)

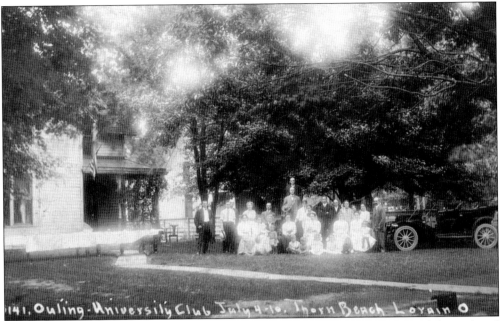

OUTING–UNIVERSITY CLUB JULY 4-10. THORN BEACH, LORAIN (3141). The University Club is gathered at the Leiter home (Thorn Beach) on East Erie Avenue. Willis Leiter is standing in the back row on the far left, and Nettie Leiter is fourth from the left with Custer Snyder to her right. Clarmont and Hildegard Doane and children are also in the photograph. The names were written on the back of this photograph by Mary Elizabeth Keller. (Courtesy of Albert C. Doane.)

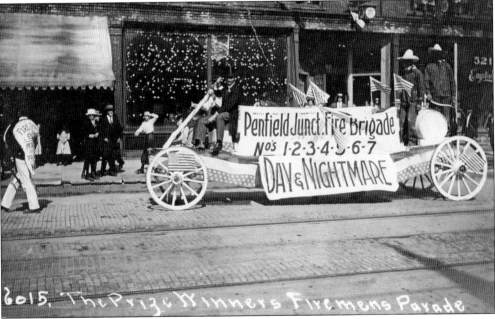

THE PRIZE WINNERS FIREMENS PARADE, LORAIN (6015). It must have been something to see this homebuilt wagon rolling down the road with no visible means of propulsion. Looking closely behind the banner, the top of a horse's head is visible. The water barrel on the back completed this prizewinning one-horse fire engine. (Bill Jackson.)

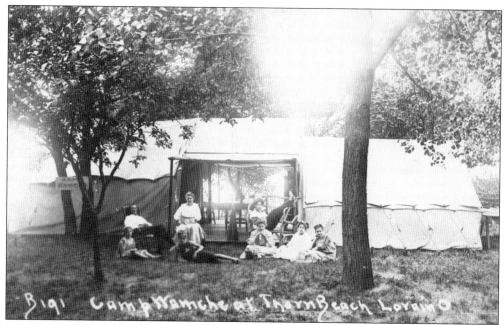

CAMP WAMCHE AT THORN BEACH, LORAIN (B191). Willis and Nettie Leiter are seen camping in the yard of their East Erie Avenue home. Willis is seated in the chair on the left with Nettie sitting next to him. Note the "Camp Wamche" sign in the trees. (Paula Brosky-Shorf.)

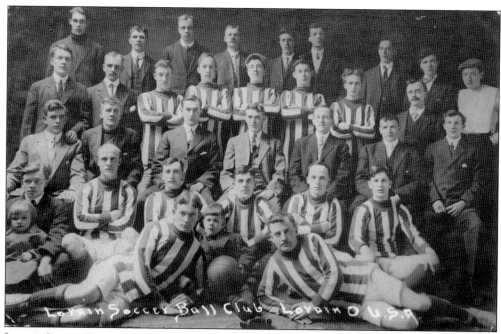

LORAIN SOCCER BALL CLUB, LORAIN U.S.A. The Lorain soccer team joined the Cleveland Soccer League in 1909. Initially, Lorain had its playing field at Avon Beach, but later moved to South Lorain. They were winners of the prestigious Bowler Cup and the Labor Cup. (Paula Brosky-Shorf.)

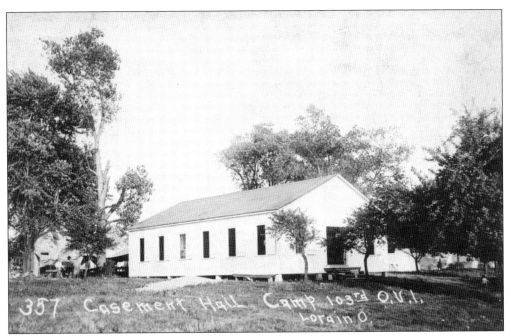

CASEMENT HALL CAMP 103RD O.V.I., LORAIN/SHEFFIELD LAKE (357). Casement Hall was named after Gen. Jack Casement, commander of the 103rd Regiment, Ohio Volunteer Infantry. He was respected and well loved by the men who served under him. (Paula Brosky-Shorf.)

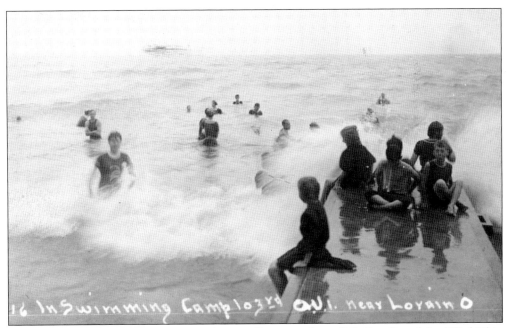

IN SWIMMING CAMP 103RD O.V.I., NEAR LORAIN/SHEFFIELD LAKE (16). Families of the 103rd Ohio Volunteer Infantry members enjoy swimming in Lake Erie and using the OVI pier on the grounds. With year-round access, it is still a popular spot today for members. (Bill Jackson.)

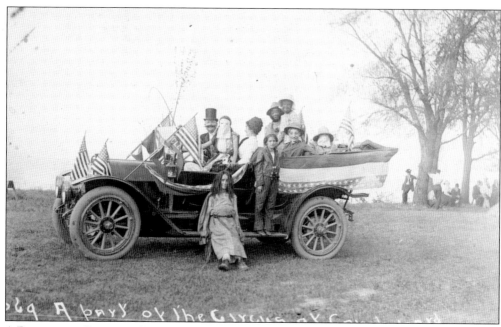

A Part of the Circus at Camp 103rd, Lorain/Sheffield Lake (69). Members of the 103rd OVI entertained each other during the annual reunion by putting on a circus. Reunions have been held in the area every year since 1866. Many activities are planned for each event. (Paula Brosky-Shorf.)

Camp 103rd O.V.I., Lorain/Sheffield Lake (1529). Families of the 103rd enjoy the OVI beach and a swim in Lake Erie. The bluffs that line the four acres on the lakeshore offer a beautiful view of the lake any time of day. (Bill Jackson.)

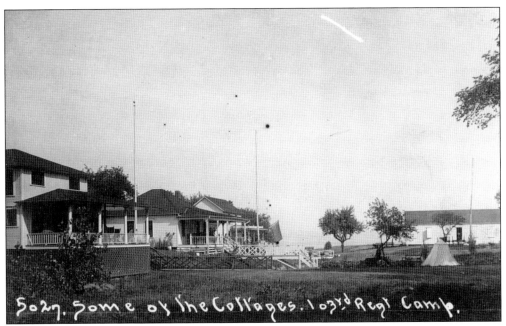

SOME OF THE COTTAGES. 103RD REGT CAMP, LORAIN/SHEFFIELD LAKE (5027). Here is a view of some of the many cottages owned by descendants of the OVI. The cottages are well maintained and most are lived in year-round. Many have wonderful views overlooking the lake. (Paula Brosky-Shorf.)

THE WEEDEN COTTAGE "LAFFALOT" CAMP 103RD O.V.I., LORAIN/SHEFFIELD LAKE. Leonard M. Weeden (inset) was the son of William Weeden, a corporal in the 103rd. William was born in 1840 in Hudson, Ohio. He enlisted for Civil War service in Company H, 103rd Regiment, August 6, 1862, at Elyria and was mustered out June 20, 1865. He died in 1908 and is buried at Columbia Center Cemetery. Leonard was born in 1868. He married Marion J. McVittie in 1898 in Detroit. He died in 1950 at the age of 82 and is buried at Columbia Center Cemetery. (Paula Brosky-Shorf.)

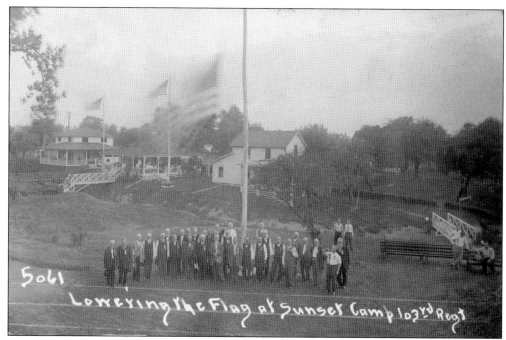

LOWERING THE FLAG AT SUNSET CAMP 103RD REGT, LORAIN/SHEFFIELD LAKE (5061). Here are members of the Ohio Voluntary Infantry during a flag lowering service. The service is held every day and night during the annual reunions. (Paula Brosky-Shorf.)

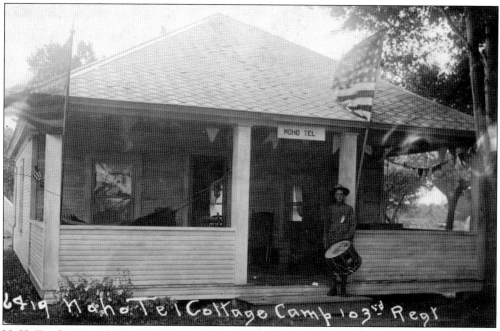

NoHoTel COTTAGE CAMP 103RD REGT, LORAIN/SHEFFIELD LAKE (6419). Many of the cottages built on the 103rd OVI grounds were given nicknames, such as "The NoHoTel" cottage seen here, and the Weeden cottage "Laffalot" on the previous page. (Paula Brosky-Shorf.)

Seven

STUDIO PORTRAITS AND MISCELLANY

THE LAUGHING BABY. The baby in this photograph is clearly charmed by the photographer. A brief note on the back tells us that her name was Rosetta W. The photograph is approximately 4 by 5.5 inches and is mounted on black matting. (Paula Brosky-Shorf.)

AN OLD-FASHIONED GIRL. This young girl is dressed in a frilly frock with her sausage curls secured by a satin bow. Seated on a wicker chair, she gazes intently at the photographer. The photograph is three by five inches and mounted on a black matte with the Leiter Lorain/Elyria O. stamp. (Paula Brosky-Shorf.)

GIRL AND BICYCLE. The young lady in this photograph poses with her bicycle. Her neatly coiffed hair is tied back to one side. Approximately 5.5 by 4 inches, the photograph is secured on a 5-by-7-inch black matte, with ornate trim and the familiar Leiter Lorain, Ohio, stamp at the bottom right. (Paula Brosky-Shorf.)

GIRL WITH TIE. A studious-looking young woman poses wearing a high-collared, pleated blouse and a wide tie. Her hair is waved and piled high on her head, secured at the back with a dark bow. She looks off to the side as the photographer takes her picture. The photograph measures 3.5 by 5 inches and is mounted on an 8-by-6-inch black matte. Leiter Studio, 312 Broadway, is embossed in the left bottom corner. (Paula Brosky-Shorf.)

THELMA EDITH. Wearing a white dress and high-button boots, the young lady in this photograph is seated on a carved bench. Her long, wavy hair is adorned with a large bow. From a note on the back, her name was Thelma Edith. Her image was made into an average-sized, 3.5-by-5.5 postcard by Leiter Studio. (Paula Brosky-Shorf.)

THE DAUGHTERS OF THE PIONEERS, LORAIN. The Daughters of the Pioneers was an organization comprised of the daughters of the old settlers of Lorain. Many of the members were born in Lorain, grew up together, and shared a deep friendship. Founded in about 1899, the first meeting was held at the home of Cassie Tillack on Washington Street (Avenue), where an estimated 15 members

came together. The first officers were Ruby Prince, president; Augusta Jones, vice president; Belle Purcupile, secretary; and Hattie Bradley, treasurer. Through the years, the ladies held parties, picnics, and annual banquets. (Paula Brosky-Shorf.)

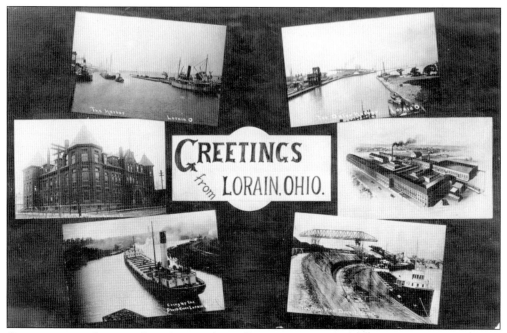

GREETINGS FROM LORAIN, OHIO NO. 1. This collage is comprised of miniature photographs from Leiter Studio. Featured are Black River Harbor, the offices of the National Tube Company, the National Stove Company, and the docks of the Steel Plant. (Paula Brosky-Shorf.)

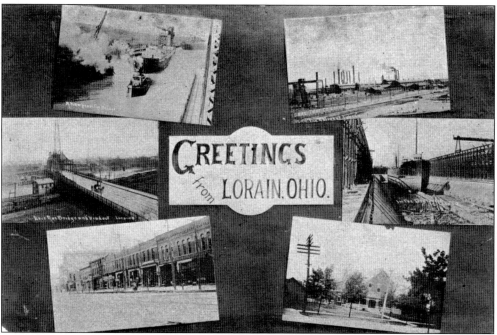

GREETINGS FROM LORAIN, OHIO NO. 2. A second photograph collage from Leiter Studio shows views of the Erie Avenue Bridge, the National Tube Company, the dry docks at American Shipyards, downtown Lorain, and the old city hall on East Erie Avenue. (Paula Brosky-Shorf.)

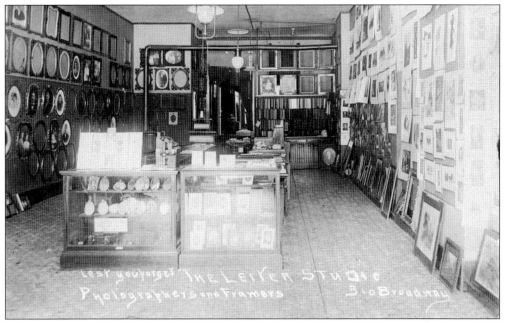

LEST YOU FORGET – THE LEITER STUDIO PHOTOGRAPHERS AND FRAMERS–310 BROADWAY. The walls of the interior of Leiter Studio are covered in elegant frames and photographs. A cash register can be seen atop the glass counter to the left. (Bruce L. Waterhouse Jr.)

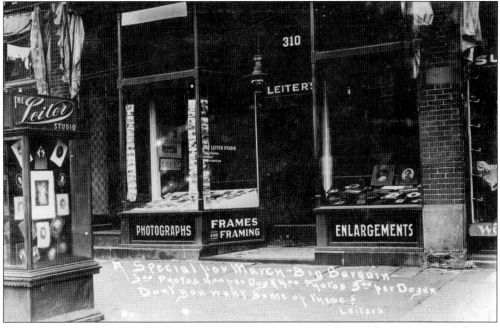

A SPECIAL FOR MARCH – BIG BARGAIN – 5.00 PHOTOS 4.00 PER DOZ & 4.00 PHOTOS 3.00 PER DOZEN. A look inside the windows of Leiter Studio reveals an assortment of frames, photographs, and postcards. A glass showcase sits on the sidewalk in front of the studio at 310 Broadway Avenue in Lorain. A note reads, "Don't you want some of these? Leiter's." (Paula Brosky-Shorf.)

Discover Thousands of Local History Books
Featuring Millions of Vintage Images

Arcadia Publishing, the leading local history publisher in the United States, is committed to making history accessible and meaningful through publishing books that celebrate and preserve the heritage of America's people and places.

Find more books like this at
www.arcadiapublishing.com

Search for your hometown history, your old stomping grounds, and even your favorite sports team.

Consistent with our mission to preserve history on a local level, this book was printed in South Carolina on American-made paper and manufactured entirely in the United States. Products carrying the accredited Forest Stewardship Council (FSC) label are printed on 100 percent FSC-certified paper.

MADE IN THE